Forests, Rocks, Torrents

Norwegian and Swiss Landscapes
from the Lunde Collection

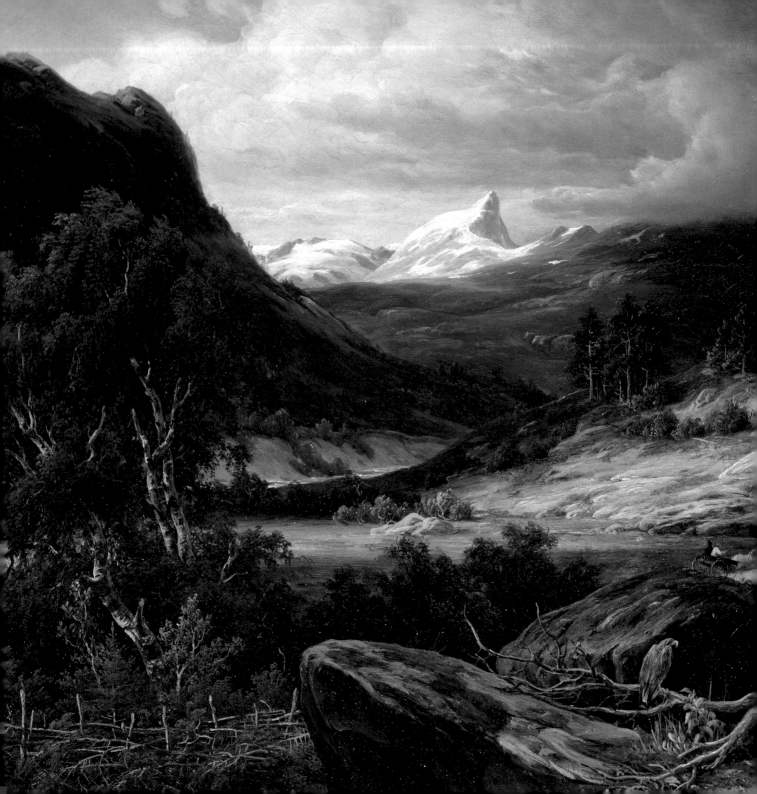

Christopher Riopelle
with Sarah Herring

FORESTS, ROCKS, TORRENTS

Norwegian and Swiss Landscapes from the Lunde Collection

National Gallery Company, London
Distributed by Yale University Press

First published in Great Britain in 2011 by
National Gallery Company Limited
St Vincent House · 30 Orange Street
London WC2H 7HH
www.nationalgallery.co.uk

ISBN: 978 1 85709 523 4
1031394

British Library Cataloguing-in-Publication Data.
A catalogue record is available from the British Library.

Library of Congress Control Number: 201093735

Publishing Director Louise Rice
Publishing Manager Sara Purdy
Project Editor Rebecca McKie
Picture Researcher Suzanne Bosman
Production Jane Hyne and Penny Le Tissier

Designed by Dalrymple
Printed in Hong Kong by Printing Express

National Gallery publications generate valuable revenue for the Gallery, to ensure that future generations are able to enjoy the paintings as we do today.

Front cover: Alexandre Calame, *The River Lutschine near Lauterbrunnen*, about 1862 [detail of cat. 45]

Page 2: Thomas Fearnley, *View over Romsdal with Romsdalhorn in the Background*, 1837 [detail of cat. 29]

All measurements give height before width

This book was published to accompany the exhibition *Forests, Rocks, Torrents: Norwegian and Swiss Landscapes from the Lunde Collection* held at the National Gallery, London
22 June–18 September 2011

This exhibition has been made possible by the provision of insurance through the Government Indemnity Scheme. The National Gallery would like to thank the Department for Culture, Media and Sport and the Museums, Libraries and Archives Council for providing and arranging this indemnity.

Contents

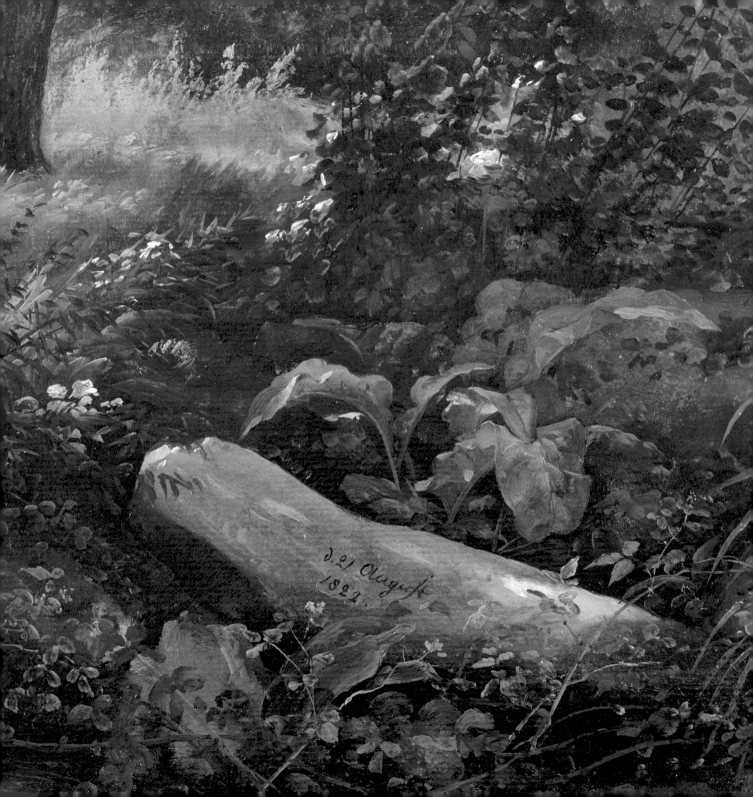
d. 21 August
1822

Director's Foreword

Soon after Asbjørn Lunde began practising as a lawyer in New York in 1950, he began to collect in many different fields: Islamic rugs and Chinese ceramics, paintings by Sébastien Bourdon and George Morland, bronzes by Aimé-Jules Dalou and Vincenzo Gemito, Indian miniatures and etchings by Giovanni Battista Piranesi. His collecting has always been animated by curiosity concerning problems of connoisseurship. He has solved many puzzles, especially among seventeenth-century French paintings, which remain a special interest. A familiar figure at auction rooms, fairs and galleries all over Europe as well as in New York, Lunde is rarely without photographs in his bag about which he is seeking expert specialist advice. He himself is now one of the leading experts on the landscape painters of nineteenth-century Scandinavia and Switzerland, which have become his chief focus as a collector.

Lunde began to buy Scandinavian paintings in 1968 when he acquired works by Knud Baade and Thomas Fearnley at auction in Oslo. Not long after, he bought a painting by Peder Balke; the following year, in London, he acquired his first work by Johan Christian Dahl (about whom his brother Karl was completing a doctoral dissertation). The two brothers' parents were Norwegians who had settled in Staten Island, which must partly explain their interest, but they were also well aware of the reputation and connections these artists enjoyed throughout Europe, and Lunde developed a passionate interest in the school of painters in Switzerland which had developed in parallel. Over the last sixteen years he has assembled a major group of works by Alexandre Calame and his Swiss predecessors, rivals and successors.

Lunde's own interest in the real landscape – whether cutting through the dense woodland to create vistas around his home in Upper New York State or tiring out his young friends while walking in the Alps – must have deepened his feeling for the paintings. But his fascination with the process of reappraisal and rediscovery is perhaps even more significant, and he has done much to encourage curators to share his interest in recently neglected artists.

Lunde has been a judicious and imaginative benefactor of numerous museums, most notably the Clark Art Institute, Williamstown; the National Gallery of Art, Washington DC; the Metropolitan Museum of Art, New York; and the Nordnorsk Kunstmuseum, Tromsø. We are delighted to be able to acknowledge him now as a supporter of the National Gallery – an institution he has long loved and admired.

Nicholas Penny
Director, The National Gallery, London

Johan Christian Dahl (1788–1857),
The Grosser Garten, Dresden, 1822
[detail of cat. 15]

Two Traditions

Christopher Riopelle

Unlike Norway, Switzerland has no jagged seacoasts on which storm-tossed ships can founder. Unlike Switzerland, Norway is the crossroads to nowhere; off in a corner of Europe, roads north peter out there into Arctic drifts and existential dread. And yet, in life as on canvas, Norwegian and Swiss landscapes often resemble nothing so much as each other [cat. 1; cat. 2]. Both nations boast snow-capped peaks, vertiginous, thinly populated valleys into which glaciers thrust their inexorable way, dense forests of fir and raging, ice-cold cataracts. And in the years around 1800, both nations generated traditions of painting that celebrated the landscape in its sublime and pastoral modes. This exhibition confronts the two traditions and asks how it is that two countries – one mired in poverty, dependent on the export of natural resources, without developed cultural institutions, and in political thrall to its Scandinavian neighbours; the other proverbially prosperous, effortlessly cosmopolitan, rapidly industrialising and, for centuries, politically independent – could have arrived more or less simultaneously at the collective realisation that landscape painting was a tool for thinking about themselves and their respective places in the world.

Norway and Switzerland stand together near the start of a tradition of national landscape painting which had international impact over some 150 years (approximately 1780–1930). Just about every modern nation, especially as political independence loomed, or in its optimistic wake, saw the virtue of depicting its own landscape in its most typical or, conversely, most distinctive and individual manifestations. The Dutch were among the first. In the seventeenth century Dutch painters proudly depicted the flat, affluent country they had won back from the sea and the Spanish, and they found an avid market among their countrymen for such self-confident works.[1] In the eighteenth century English painters came to celebrate their green and pleasant land, and the economic sway the landed gentry held over it. Often, landscape painting and politics were inextricably mixed. In nineteenth-century Russia a landscape painting might encrypt a call for the emancipation

Thomas Fearnley (1802–1842),
Tree Study, by a Stream, Granvin, 11 July 1839
[detail of cat. 28]

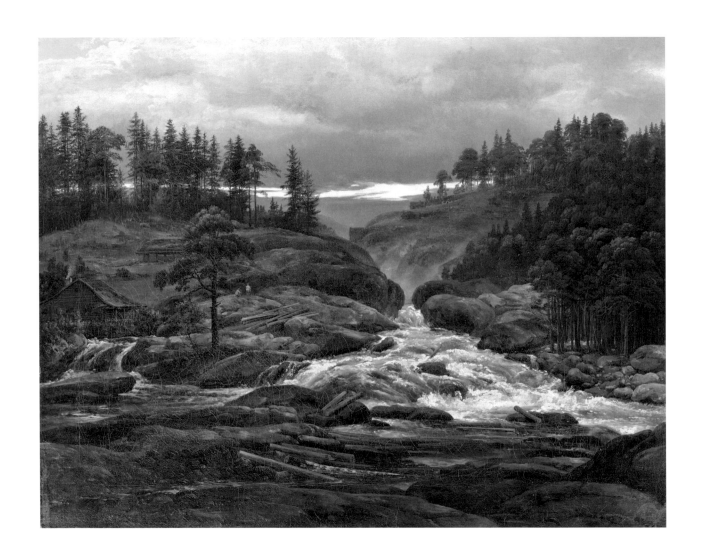

1 Johan Christian Dahl (1788–1857)
The Lower Falls of the Labrofoss, 1827

Oil on canvas · 51 × 66 cm

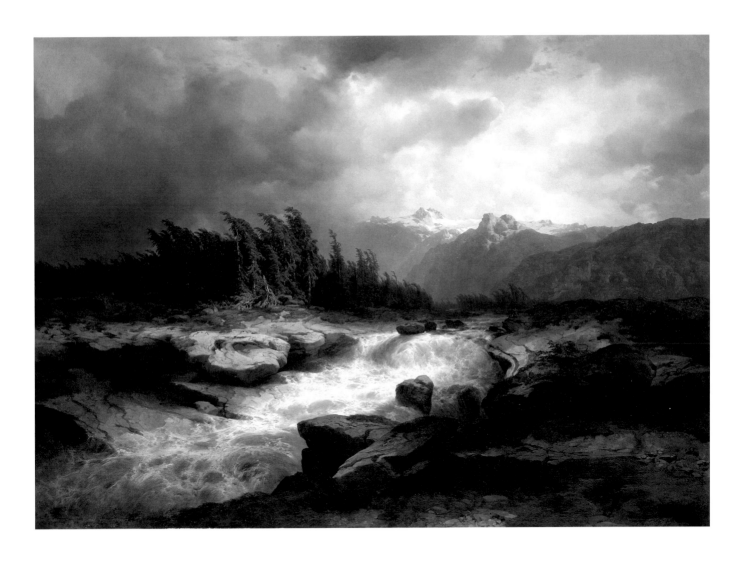

2 Alexandre Calame (1810–1864)
Mountain Torrent before a Storm (The Aare River, Haslital), 1850

Oil on canvas · 98.1 × 137.8 cm

of the serfs or speak to the terrors of Siberian exile.[2] Later, painters across Europe and North America turned to such subject matter not only as a vehicle for self-reflection but, looking outwards, for self-promotion as well. The painting of the American West, magnificent in its sweep and ambition, went hand-in-hand with the expansion of the railroad, and the population surges and mass tourism that came in its wake.[3] Everywhere, painters discovered they could speak directly to their countrymen through the medium of landscape about the history, culture and values they shared, and to the wider world about the collective pride and anxiety they felt for their homelands.

As it had for the Dutch two centuries earlier, nineteenth-century national landscape painting also became a tool for bringing new audiences to art. Prosperous, middle-class citizens with burgeoning cultural aspirations no longer found inspiration in religious or mythological scenes but wanted instead to see in art an examination of the lives they themselves were leading, the fields and forests, mines and mills

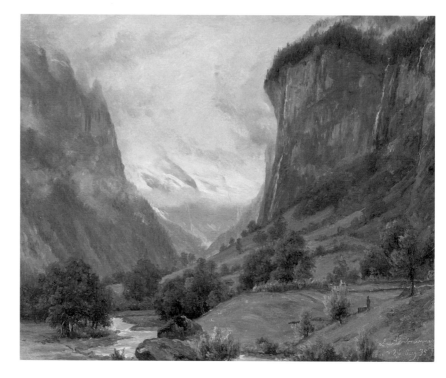

3 Thomas Fearnley (1802–1842)
Near Meiringen, 10 June 1835
Oil on paper, laid down on canvas · 27.3 × 36.8 cm

4 Thomas Fearnley (1802–1842)
Valley of Lauterbrunnen, 26 August 1835
Oil on paper · 27.3 × 33 cm

from which they derived sustenance. Landscape painters, attuned to the new aesthetic possibilities made available by the Romantic imagination, filled this need. Their images not only reflected burgeoning national consciousness but helped to shape it. In 1832 the Norwegian Peder Balke (1804–1887) made an expedition to the isolated far north of his native land which introduced his fellow Norwegians to aspects of the landscape, mesmerising in its austere grandeur, very few of them could otherwise have seen. For generations of tourists on their way south to Italy, and again on their way home, the Swiss Alps became an imposing, indeed inescapable object lesson in the aesthetic category of the Sublime.

In quite a different context, Renoir once said of his aim in painting a portrait that, looking at it, a mother must always be able to identify her child. The same can be true of landscape. The connoisseur of national landscape painting was looking for specific mountains, identifiable villages, waterfalls whose names he knew. Thus, it was in essence a realist tradition, wedded to specific natural phenomena and

to verisimilitude in their depiction. Even when, as the nineteenth century progressed, French Impressionism and later avant-garde modes influenced painters to adopt increasingly loose and improvisational styles, a paramount concern remained motifs the viewer could point to in recognition.

This is particularly true of the pictures in this exhibition. At first glance, they hoe a narrow stylistic row, as all are painted in a highly detailed, intensely realistic manner. (It is the aesthetic to which Asbjørn Lunde as a collector of paintings most intensely responds.) All are marked as well by technical virtuosity in drawing and paint handling, representing the most exacting standards as taught in the academies of Europe until a century ago. Indeed, in almost every instance an attentive geologist, archaeologist or historian of agriculture might be able to derive specific information from these pictures about a given site. (Only Balke here aimed for broad general effects in his later seascapes and as such stands out as a fascinating aberration in the collection, and indeed in the Norwegian tradition as a whole, cat. 12)

Slowly, however, individual hands and distinctive artistic personalities emerge. The attentive viewer soon differentiates the Norwegian Johan Christian Dahl (1788–1857) from his brilliant student Thomas Fearnley (1802–1842), the Swiss Alexandre Calame (1810–1864) from his epigone Johan Gottfried Steffan (1815–1905). As these artists knew, a commitment to realism in no way implied the suppression of individual artistic sensibility.

The paintings here, whether Swiss or Norwegian, are of two principal kinds, landscape oil sketches, all small in scale, and 'finished' paintings, some small, some large, some very large. Many of the sketches were painted outdoors in front of the motif. Those motifs are often simple – rock scree, a fallen tree trunk, a mountain hut. The sheets are often annotated with specific dates and locations. Such works were assembled by the artists as they travelled from motif to motif, visual data which might or might not be referred to later back in the studio as they worked up more elaborate landscape compositions. At the time of their making they were not thought

5 François Diday (1802–1877)
The Wetterhorn with Upper and Lower Grindelwaln Glacier, date unknown
Oil on panel · 44.5 × 58.3 cm

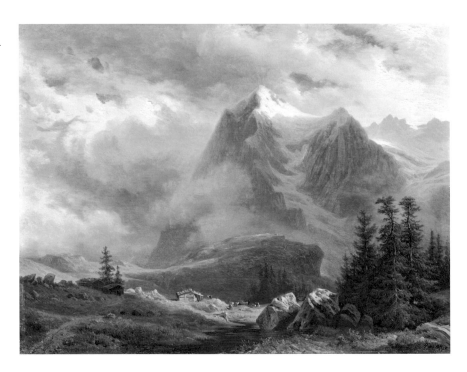

14 of as fully resolved works of art and were rarely exhibited. 'Finished' paintings such as Calame's monumental *Mountain Torrent before a Storm (The Aare River, Haslital)* [cat. 2], on the other hand, are carefully composed productions based on close study of a commanding landscape motif, but brought to perfection – that is to say, to balance, tonal unity and almost hypnotically sharp focus – after long reflection in the studio. Such works were considered the summit of art, reserved in their day for the most discriminating collections. The Calame once hung in a St Petersburg palace.

Fearnley, for his part, often brought small, seemingly candid sketches to a high degree of completion and exhibited them as finished works. And it is with this Norwegian master, cut down in his early prime, that the Norwegian and Swiss landscape traditions intersect. On his way north towards home after three years in Italy, Fearnley spent the summer of 1835 in Switzerland. There he painted a remarkable series of oil sketches of the lakes, mountains and passes so characteristic of the Alpine landscape – and so reminiscent of Norway too – three of which, all inscribed with date and place, are in the Lunde collection [cats. 3, 4 and 6]. Did any Swiss artists see these works, which in some cases anticipate their own engagement with similar Alpine motifs? It is impossible to say. Like Fearnley, however, both Diday [cat. 5] and Steffan [cat. 7] would later paint the Wetterhorn, and it is possible to contrast three 'takes' on that mighty peak in the present exhibition and above.

If the exhibition allows the viewer to compare nineteenth-century Norwegian and Swiss landscape paintings, underscoring their evident similarities, it also asks questions that probably cannot be answered at this early stage in the comparative study of the two traditions. They concern the differences that climate, character,

6 Thomas Fearnley (1802–1842)
The Mountain Wetterhorn, 18 July 1835

Oil on paper · 30.8 × 28 cm

7 Johann Gottfried Steffan (1815–1905)
Near Meiringen (The Wetterhorn), 1846

Oil on canvas · 34 × 35.9 cm

national temperament and political regimes impose on art. In what ways, if at all, are these realities implicated in the paintings we see? How do we tease out such elusive meanings? It is the strength, and the provocation, of the Lunde collection – the most comprehensive of its kind in private hands, including unparalleled suites of paintings by Dahl, Fearnley and Calame – that it provides the visual evidence we need to frame the questions properly. At the same time, it expands our understanding of the vital role national landscape painting once played in European culture.

1 The classic text on the development of the distinctive motifs of Dutch landscape painting remains W. Stechow's *Dutch Landscape Painting of the Seventeenth Century*, New York 1966.

2 On the Russian example, see D. Jackson and P. Wageman, eds., *Russian Landscape*, exh. cat., Groninger Museum, Groningen, and National Gallery, London, 2004.

3 On the American tradition, see A. Wilton and T. Barringer, *American Sublime: Landscape Painting in the United States, 1820–1880*, exh. cat., Tate Britain, London; Pennsylvania Academy of the Fine Arts, Philadelphia; Minneapolis Institute of Arts, 2002.

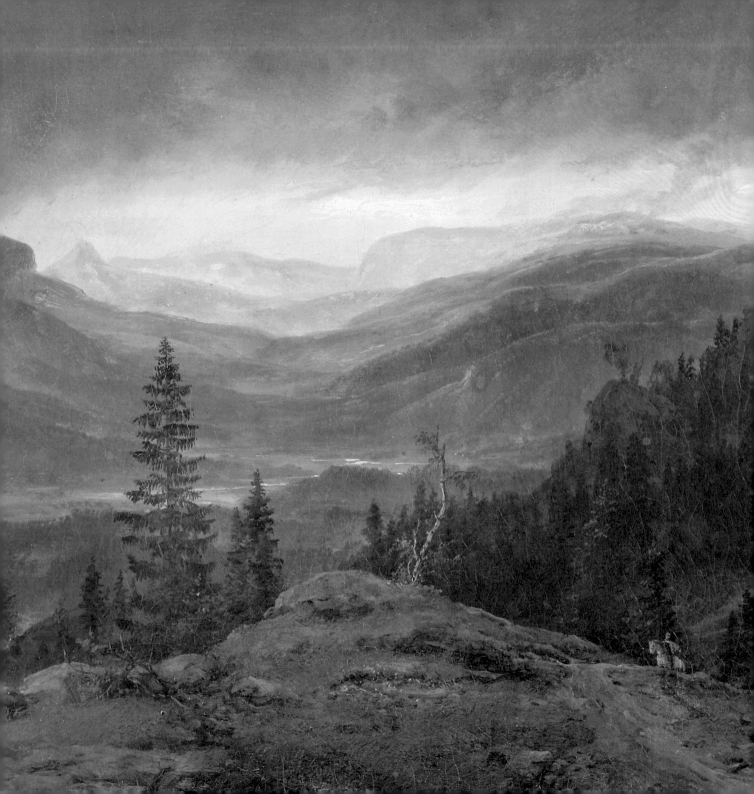

Norway in the Mind's Eye

Christopher Riopelle

The Norwegian painter Johan Christian Dahl (1788–1857) arrived in Rome in the summer of 1820. He found himself among a large and gregarious international community of artists, including Danes, Germans, English, Swiss and French. Like generations before them, they had been drawn to Italy by the lure of antiquity, the Old Masters to be seen there and – especially appealing to the landscape painters among them – the brilliant Italian sunlight that etched forms vividly against the sky. Dahl and his new companions pored over the monuments of the Eternal City and organised sketching expeditions to the Campagna, the sun-blasted countryside adjacent to the city. The artist then spent several months working in and around Naples [cat. 14] but was back in Rome early the following year to continue his detailed investigation of the local scene, sketching, collecting botanical specimens and planning landscape compositions on Italian themes. His companions were surprised, then, when at the same time Dahl began to paint large and complicated canvases depicting the rugged landscape of distant Norway.[1] Surely these alien inventions had no place on an Italian sojourn. Dahl confused his friends further with the enigmatic assertion that he saw no contradiction whatsoever, for '... one should live in Rome among art and artists to really appreciate the Northern scenery.'[2]

Dahl loved Norway with the passion of a patriot. From the start of his career, he committed himself to depicting it. But he faced the expatriate's eternal dilemma, for, as he discovered about himself early on, distance from Norway was a prerequisite of his art. In 1811 he had left his native Bergen to enter the Royal Academy in Copenhagen. Norway at the time was under the political sway of Denmark and until 1814, when control passed to Sweden, Copenhagen was the capital of the awkwardly united kingdom. The city boasted great works of art. Dahl had access, for example, to the superb Dutch paintings in the royal collection. There, he studied seventeenth-century painters such as Allart van Everdingen and Jacob van Ruisdael who had made a speciality of turbulent Nordic scenes. Their paintings offered impeccable

Fig. 1 | Johan Christian Dahl,
View over Hallingdal, 1844 [detail of cat. 18]

Fig. 2 | Caspar David Friedrich (1774–1840),
Dolmen in the Snow, 1807, oil on canvas, 61.5 × 80 cm.
Gemäldegalerie Neue Meister, Dresden

Fig. 3 | Johan Christian Dahl (1788–1857),
Winter at the Sognefjord, 1827, oil on canvas, 61.5 × 75.5 cm.
National Museum, Oslo

18 Old Master precedent for the kind of work Dahl knew he wanted to do, and his early landscapes owe them a formative debt.[3] In Copenhagen Dahl also met artists such as C.W. Eckersberg (1783–1853) who were forging a distinctive Danish school of painting, in part because they had lived abroad in Paris and Rome and brought home with them a level of European sophistication still largely unknown in hardscrabble Norway.[4] At the same time, he studied early Scandinavian architecture and the scattered evidence of a prehistoric northern civilisation older than Greece and Rome. His teacher was the leading Danish archaeologist of the day;[5] throughout his career, Dahl's instincts invariably drew him to the most accomplished people in whatever milieu he embraced. Placid, pastoral Denmark offered little by way of dramatic scenery, however – at least nothing to compare with Norway – and Dahl grew slightly bored. If Denmark opened his eyes to the wider world, simultaneously it drew his attention, and affection, back to the isolated, rugged land he had left behind.

In 1818 Dahl moved on from Copenhagen to the Saxon capital of Dresden. He returned there again after the Italian trip of 1820–1 and would make his career in Germany. Any idea of relocation to Norway had been quickly abandoned for practical reasons; there was little art and it would be impossible for an artist to make a living. As Dahl wrote, 'I would like to have been in Norway, but I could not live there, as there are too few art lovers and works of art. If one is to progress in the arts, these are just as necessary as beautiful scenery.'[6] In Dresden he became a close friend and, for a time,

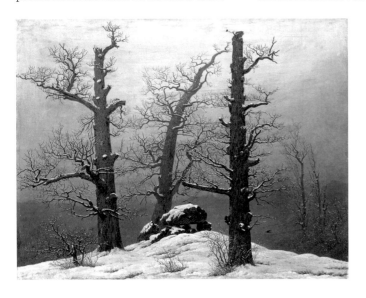

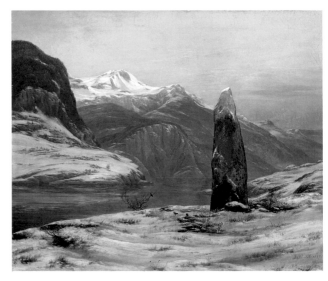

room mate of the most innovative landscape artist of the age, Caspar David Friedrich (1774–1840), himself a former student at the Copenhagen Academy. Fourteen years Dahl's senior, Friedrich too was interested in vestiges of early civilisation such as the dolmens that dotted the North European countryside. As early as 1807 he began to explore the ways in which they endowed the landscape with a spiritual resonance [fig. 2]. Dahl understood the implications of Friedrich's images. The ancient menhirs (upright stones marked with Viking inscriptions) to be found in distant corners of Norway would become a staple of his art [fig. 3, cat. 17]. For Norwegians learning to think about their nation's past, they were uniquely evocative motifs; for Dahl's growing numbers of foreign admirers they communicated the age-old mystery of the impenetrable north.

In time, Dahl became a Professor at the Dresden Academy and a significant figure in the German art world. He painted scintillating views of Dresden – silvery cityscapes showing its baroque skyline under a full moon are among his distinctive creations – as well as

landscapes along the Elbe [cat. 16] and in the Tyrol. But Norway remained central to his imagination. In his youth he had sketched a repertoire of distinctive landscape motifs there. He brought them with him on his travels. For some fifteen years they served as references, repeatedly consulted when the spirit, or patrons with lucrative commissions, moved him to paint Norwegian scenes. Even as Dahl's considerable technical facilities as a painter grew, these relatively primitive early notations continued to serve their purpose. It was on such *aides-mémoire* he relied in Rome in 1821.

Beginning in 1826 and continuing until 1850 Dahl undertook a series of five return visits to Norway, usually in summertime. He journeyed to eastern valleys amid snow-capped mountains, western fjords and the jagged sea-coast near Bergen to replenish his stock of motifs. He also indulged his continuing scholarly interest in the prehistory of Norway and its artefacts. Along the way, he executed hundreds of closely observed sketches in pencil and oil paint as he absorbed the distinctive details of his native landscape. Back

in his studio they in turn served as sources over the coming years for ever more ambitious Norwegian scenes. Soon, Dahl was famous among Norwegians as their esteemed master in exile. A pilgrimage to Dresden to sit at his feet became an obligatory rite of passage for young artists from the north making their way southwards. He urged them, too, to take up the Norwegian theme but, as with his most important disciple, Thomas Fearnley (1802–1842), didn't seem to mind if they chose to do so from Italy.[7]

In at least one instance it is possible to trace Dahl's working method across various media. On 26 August 1850 he made a pencil drawing of a distinctive rock, like the head of a primordial beast, at Nystuen on Filefjell, covering the sheet with annotations concerning details of the scene and colours, and dating it. The next day – back in his studio? still in the open air? – he made a vivid oil sketch of the same characterful rock [cat. 22], inscribing on the rock face itself the date 27 August 1850. The same rock then reappears as an important detail in a later, larger and highly finished landscape.[8] This

manner of working – landscape sketches made *sur le motif* which were then used as sources for large-scale compositions painted in the studio – was in danger of becoming slightly old-fashioned by the second quarter of the nineteenth century, as an aesthetic that extolled spontaneity of execution slowly gained favour. For Dahl, however, mere sketching was inimical to the task of true landscape painting. His friend Friedrich would have agreed. Rather, the oil sketch should be as true to visual reality as possible, full of closely observed atmospheric effects and suggestive of the unique, fleeting phenomena of nature. Even if it were never used in the process of developing a larger, finished composition, it played an important role in training the hand and the eye of the artist. No effort was wasted.

But the sketch was a means to an end. The real work of creation took place not out painting by the side of a fjord or under a parasol in the Campagna, but back in the studio. There, the artist sifted in his mind the variety, not to say the cacophony, of visual stimuli to which he had been exposed. He edited the visual experiences nature had put his way, took them apart, analysed them, and then slowly, laboriously reassembled them in classically balanced landscape compositions that, cumulatively, were truer to the larger, deeper reality of Norway – or of Italy, or Dresden, as the case might be – than any number of individual studies would allow. Even though upon Fearnley's premature death Dahl urged the National Museum in Oslo to acquire his oil sketches along with finished compositions, so that both aspects of the creative process were represented in the national collection (a step too far; the museum declined) for Dahl himself there would be 'no convergence between the study and the finished work.'[9]

A painting like the *Lower Falls of the Labrofoss* of 1827 [cat. 1], executed for an English client,[10] results directly from Dahl's long study of the Norwegian landscape at its most tumultuous. At the same time, it is the product of slow and painstaking studio work. There, the elements of the landscape find harmonious alignment on canvas, cognate with but different in kind from the harmony of nature. The sharpness of focus in the painting, for example, uniform across the canvas, belies the haphazard and partial way in which such a panoramic view would be taken in by the human eye in front of the motif itself. For Dahl, the aesthetic merit of the painting lay not in the motif but in the artist's ability to ennoble it. It was this higher, more complete vision – the eternal Norway of the mind's eye, fruit of long reflection – at which Dahl always aimed.[11] (Friedrich said that, for his part, he studied landscape 'through the inner eye.'[12] One can imagine long hours of studio conversation over the years as the two friends articulated to one another their related, although not identical, positions on landscape painting.) And it was for this reason that it did not matter where Dahl was when he chose to paint Norway. The snowy peaks, the cascading torrents, the impenetrable forests of the true north did not need to be in his line of sight; rather, memories of Norway, contemplated in the tranquillity of the studio, could be prompted by oil sketches made on the spot, and by long years of

aesthetic experience too. This is what Dahl meant when he told his Roman companions that, among sympathetic fellow artists and surrounded by great art of all ages, Rome was a fine place indeed to paint Norwegian scenes.

Dahl was the *fons et origo* of the Norwegian landscape tradition. His lifelong oscillation between an intimate engagement in the physical reality of Norway, and the distance and detachment demanded by art, influenced the tradition as a whole. He was not the first to paint Norway. The practice began to emerge in the later eighteenth century, often allied with topographical investigations.[13] The Danes Erik Pauelsen (1749–1790) and Christian August Lorentzen (1749–1828) travelled in Norway in the years before 1800, worked up oil paintings recording their visits, and published prints after them. In 1799 the Swede A.F. Skjöldebrand (1757–1834) may have been among the first to depict the Midnight Sun and the *aurora borealis* or Northern Lights as well.[14] An image of Norway as a land of rocks, glaciers, waterfalls

and uncanny radiance, only minimally touched by the hand of man, was slowly entering into circulation at home and abroad. Writers of a Romantic disposition were also taking up the theme. For both artists and writers, depictions of Switzerland (on which see here the essay by Sarah Herring, pp. 53–61), which is so similar to Norway in the variety, irregularity and grandeur of its landscapes, but – lying as it does at the crossroads of Europe – so much more accessible to the curious traveller, were an important precedent. Indeed, if by 1800 'the Alps represented the idea of the *sublime* [and] provided an outlet for the powerful emotional experience that the times now craved,'[15] then it seemed these same heady emotions could be transferred *en bloc* to the frigid north.

Dahl himself seemed to appreciate the reciprocity between the two mountainous lands. He had long planned to visit Italy by way of a leisurely Swiss sojourn.[16] In the event, he received an invitation he could not refuse – a Danish prince; a Neapolitan palace – and hurried south via the Tyrol instead. In Rome in 1821 he collaborated with

the German artist Joseph Anton Koch (1768–1839), adding a goatherd and goats to the foreground of the latter's depiction of Lauterbrunnental in Switzerland (Thorvaldsen Museum, Copenhagen).[17] Soon after, he swapped his painting of a Norwegian glacier for a work (which might well have been an Alpine landscape in turn) by the Swiss painter Hieronymus Hess (1799–1850).[18] Dahl would also see his most brilliant student cement the Norwegian-Swiss bond when, on his own way home from Italy, Fearnley spent the summer of 1835 in Switzerland painting jewel-like depictions of Alpine scenery [cats 3, 4 and 6]. Had the artist not taken care to inscribe them with locations, they might almost be mistaken for their Norwegian equivalents.

This growing appreciation of the distinctive Norwegian landscape, and an intuition that the new-found interest related to wider international concerns, was the context in which the young Dahl took up his brush. What he brought to bear that was new, beyond a technical dexterity previously unknown in Norwegian painting, was a

commitment to Norway as a full partner in European art. Isolated though the country was, off in a far corner of Europe; as harsh a stand-off with the elements as life there might prove to be much of the year; although Norwegian political freedom was still only a half-articulated dream; Dahl's impertinence was to call on his fellow Norwegian artists to enter into the complicated, centuries-old dialogue that was the European painting tradition. For him, personally, it meant making his career abroad, for in greater Europe he could commune on a daily basis with that wider tradition. No matter. One eye was fixed on home. Among the functions Dahl served as exiled *éminence grise* was talent scout. In 1836, for instance, he brought the bright young landscape painter Knud Baade (1808–1879) from his homeland to Dresden for three years of study and fecund exposure to Friedrich and German Romanticism, then in full sway. In his moonlit scenes of storm-tossed coasts, Baade created the operatic image of a mythical Norway inhabited by warrior princes from a bygone era of bards and sagas [cat. 8]. He would go

on to a distinguished artistic career in Munich, where he continued to turn out Norwegian scenes which were increasingly Wagnerian in tenor. Such works established his international reputation; two Norwegian sea pieces had made their way into the Victoria & Albert Museum during the artist's lifetime.[19]

This is not to say that Baade was not also a close observer of humble Norwegian life, which he recorded in naturalistic sketches of a limpid clarity and directness [cat. 9]. Indeed, naturalism was the dominant mode of landscape painting, and the focus of Norwegian artistic ambition, for the first three quarters of the century. Formative influences came from abroad, particularly the academy in Düsseldorf, where many Scandinavian artists studied. The qualified realism promoted there, with an emphasis on the establishment of a dominant, often melancholic mood in landscape, was considered advanced for the time (though high-keyed Parisian modernism would soon overwhelm it) and proved widely influential as far away as America. Indeed, 'a standard

Düsseldorf style soon came to dominate Nordic landscape painting.'[20] Hans Gude (1825–1903) studied there and went on to head the Düsseldorf academy – he also taught in Karlsruhe and Berlin – but also travelled widely, including sketching trips to Wales and Scotland. Deceptively simple but highly finished works like *By the Mill Pond,* dominated by a mossy rock, show his skill at rendering natural phenomena with an attention to detail worthy of a botanist [fig. 4]. But it is not a sketch. Here, Gude borrows a highly sophisticated compositional strategy from Friedrich. A pensive female shown from behind stares into the churning waters and, because we cannot see her face, we are invited to intuit her emotions, or to project our own upon her. Such works demonstrate a recent scholar's characterisation of the Nordic character in painting at this time as 'alongside the feeling for nature ... an underlying mood of earnestness, stillness and longing.'[21]

Fearnley (his grandfather was a Yorkshireman) was Dahl's most accomplished Norwegian student and has long been appreciated for his

distinctive landscape vision. Like Gude at his most deceptively informal, he was drawn to unexpected points of view and natural phenomena, and applied that vision with equal intensity wherever he travelled in Europe.[22] He and Dahl met in 1826 when they painted together in Norway; Dahl urged him afterwards to specialise in Nordic scenes, which he did, sporadically. Fearnley was a peripatetic soul, however, and thrived in the warmth of the sun, spending three years in Italy beginning in 1832 [cat. 26]. There, he was fascinated by fantastical outcroppings of rocks [fig. 5; cat. 24], and

his view of a sun-dazzled Palermo sprawled languidly beneath a looming and starkly faceted Monte Pellegrino anticipates nothing so much as Paul Cézanne's depictions of Mont Sainte-Victoire 60 years later [cat. 25]. Previously, Fearnley had visited his mentor in Dresden in 1829 and 1830 and, like him, painted pastoral landscapes along lazy stretches of the Elbe [cat. 31]. In Switzerland in the summer of 1835, on the other hand, he delighted in the imposing Alpine peaks, depicting distinctive Swiss motifs in advance even of Helvetic masters such as Alexandre Calame (1810–1864).

Soon he was on the move again, painting indefatigably as he went. In addition to pure sketches he executed small, colourful works out of doors which he described as 'finished' and exhibited as such. Habitually, the surface of the canvas or paper is entirely covered in delicate strokes of colour in which subtle distinctions in the play of light are rendered with hypnotic precision. At the same time, he eschews traditional composition in favour of casual-seeming oblique views on to dominant landscape motifs; snapshots *avant la lettre*. An 1837 visit to the Lake District gave rise to nature

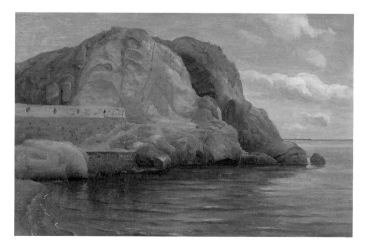

Fig. 6 | August Strindberg (1849–1912), *Storm in the Skerries: 'The Flying Dutchman'*, 1892, wax colour on cardboard, 62 × 98 cm. Statens Museum for Kunst, Copenhagen

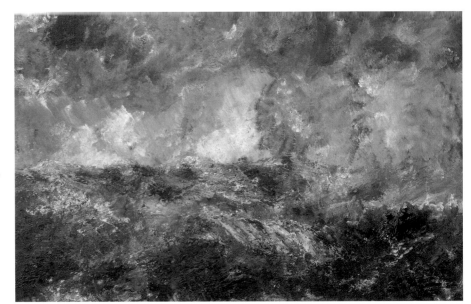

Fig. 7 | Peder Balke (1804–1887), *The Tempest*, about 1860, oil on wood panel, 6.5 × 5.5 cm. The National Gallery, London, presented by Danny and Gry Katz, 2010.

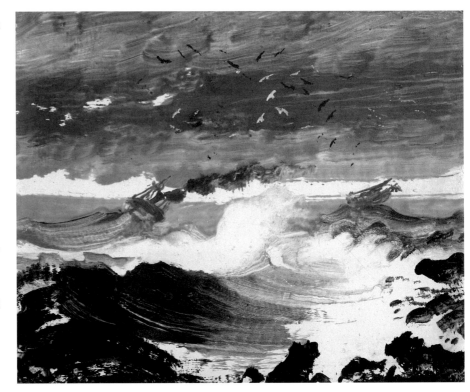

studies which still surprise by their originality; had anyone before Fearnley at Derwentwater thought to structure a landscape around the elegant arabesque of a fisherman's rod and reel [cat. 27]? The artist, coming fully into his own artistically at the age of 39, contracted typhus. His sudden death deprived Norwegian art of the mature work of a distinctive master.

The broad outlines of the Norwegian landscape tradition have long been known to Scandinavian scholars, if less widely appreciated elsewhere. Even there, however, one artist of the utmost inventiveness managed to slip beneath the radar of critical attention. Local historians began to discover traces of him earlier in the twentieth century, but only now is Peder Balke (1804–1887) emerging in international eyes as a master of Norwegian landscape, the subject of exhibitions, scholarly publications and bidding wars in auction rooms. Outside Scandinavia, moreover, he is increasingly celebrated as a precocious proto-Modernist. His visionary concept of landscape and improvisatory handling of paint are seen to anticipate the expressionist

innovations of twentieth-century art, much as his Swedish contemporary, the playwright and polymath August Strindberg (1849–1912) has also been lauded in recent decades for his obdurate, encrusted landscapes not unlike the *art brut* of a later era [fig. 6]. The year 2010 saw the first work by Balke enter a British public collection [fig. 7].

Born in poverty, Balke trained in Christiania (Oslo) as a painter-decorator before moving on to Stockholm for a more traditional academic art education. Early paintings reveal nothing more than provincial competence and a conventional grasp of landscape. In 1832, however, he travelled by sea to Norway's isolated North Cape, a wild place of mountains rising straight from the ocean waves, buffeted by storms and pitilessly inhospitable to man – Norway *in extremis* – which would provide him with a lifetime of distinctive landscape motifs [cat. 10]. Balke was ambitious and something of an entrepreneur. In 1835 he made obligatory contact with Dahl in Dresden, visiting him again in 1843. He painted a shipwreck after a Dahl canvas, thus appropriating

one of the master's distinctive motifs [cat. 19] and discovering the subject central to the art of his later years.[23] The following year, 1844, the two artists travelled and worked together in Norway. By the time they met again, in 1847, Balke was living in Paris and, astonishingly, had secured a major commission for paintings from Louis-Philippe, the King of the French. Years before, Louis-Philippe, in exile from the French Revolution, had also travelled to the North Cape and, filled with nostalgia for the bleak scenes he had encountered there, and charmed by the gruff Norwegian artist trying his luck in France, now commissioned a series of north Norwegian views from him. Revolution intervened again. Louis-Philippe was overthrown in 1848 and the commission abandoned, although today 28 oil sketches for it hang in the Louvre.[24]

Balke's *Moonlit View of Stockholm* [cat. 11], the spires of the city silhouetted against a stormy night sky, shows the direct influence of Dahl's views of Dresden but evinces a distinctively fluid play of paint. At the same time, it bridges the gap between the naturalism

of the early century and the greater expressivity found in Scandinavian landscape painting near its end in works by artists like Eugène Jansson (1862–1915) [fig. 8]. Other works by Balke, of trees isolated against distant mountains, suggest knowledge of Japanese prints, not only in composition but also in the use of unexpectedly vivid colour combinations [cat. 13]. Such paintings, as original as they are, were meant to attract a traditional, bourgeois clientele. (Like Strindberg, Balke was blithely convinced his work sat squarely in the mainstream.)

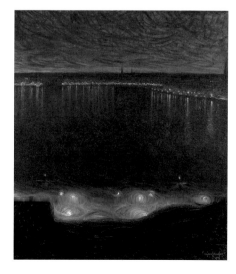

By 1860, however, his career as a painter had foundered and he turned his talents to politics and social issues instead. He enjoyed success as a real estate developer. Privately, however, Balke continued to paint for pleasure. His scenes of storms at sea and shipwrecks on rocky coasts are for the most part small black and white improvisations thinly painted on canvas or board covered in smooth white ground [cat. 12]. Works of the greatest intimacy, they must have been painted in the solitude of the studio, board in one hand, brush in the other, as he conjured crashing waves from the very flow of paint. It is these resolutely private works executed late in life by the widely travelled, passionately engaged Balke that most vividly announce a unique landscape sensibility, and the dawn of a new age in Norwegian landscape painting.

The greatest and most cosmopolitan Norwegian artist of modern times, Edvard Munch (1863–1944) said of the monumental cycle of allegorical paintings on Norwegian subjects he completed in 1916 for the Aula or Festival Hall of the University of Oslo, that they were at once 'distinctively Norwegian and universally human.'[25] Munch understood the dialectic at play when an artist addresses such themes. The works must define the national experience in a way that speaks to the artist's countrymen. When the world turns its eyes to Norway, they are required to communicate the national character and ethos abroad. (For years, the Nobel Peace Prize was presented at the Aula). It is not enough for a nation to share a sense of itself among its own people; the lineaments of national identity must also be broadcast, and recognised, beyond its borders. It is a lesson Munch may well have learned from his Norwegian forebears of the previous hundred years, Dahl first among them. Norway was their dominant, although never exclusive, subject matter. But their careers, much of their clientele, their life experiences, all were international in outlook. Even if they never felt completely at home in Italy, the Norwegians knew that they needed to absorb the art and the ageless swirls and eddies of artistic inspiration at play there. Germany, later Paris, and sometimes London, were by turns necessary stopping-off places as well, as they assumed roles as centres of creativity. Careers could be built there. Innovation would be prompted far from the fjords, but inevitably the lessons learned abroad would focus the confrontation with Norwegian themes. Inevitably, too, the work would come to be assessed abroad. Like Munch, today Dahl, Fearnley and Balke belong to a wider world beyond Norway, one they had always embraced, and which is now coming to recognise their startling originality.

1 These include two Norwegian landscapes painted in Rome for the Danish sculptor Bertel Thorvaldsen (1770–1844), long resident in the Eternal City, M.L. Bang, *Johan Christian Dahl 1788–1857: Life and Works* (3 vols), Oslo 1987, nos. 309, 312.

2 Cited in Bang 1987, vol. 1, p. 59.

3 Dahl also painted two copies after paintings by Ruisdael (both in the Nasjonalmuseet, Oslo; Bang 1987, nos. 38, 39.) On the relationship between Dutch seventeenth-century and Scandinavian nineteenth-century landscape paintings, see K. Monrad, 'The Dutch Dimension in Danish Golden Age Landscape Painting,' in *Two Golden Ages: Masterpieces of Dutch and Danish Painting*, exh. cat., Rijksmuseum, Amsterdam, and Statens Museum for Kunst, Copenhagen, 2001, pp. 16–71.

4 On the formation of the modern Danish painting tradition, see most recently P.G. Berman, *In Another Light: Danish Painting in the Nineteenth Century*, London 2007.

5 Christian Jürgensen Thomsen (1788–1865). As well as being a teacher, Thomsen was an early patron of Dahl's. In recognition of their friendship, years later Dahl presented Thomsen with a moody Norwegian landscape now in the Lunde Collection, *View over Hallingdal* of 1844 (cat. 18).

6 Quoted in Bang 1987, vol. 1, p. 19.

7 On Dahl's advice to Fearnley, see *A Brush with Nature: The Gere Collection of Landscape Oil Sketches*, National Gallery, London, 1999, cat. 28, p. 86.

8 The drawing of the rock, dated 26 August 1850, is illustrated in Bang 1987, vol. 3, pl. 478. Bang suspects that the oil sketch in the Lunde Collection showing the same rock and dated the following day (Bang 1987, no. 1114; cat. no. 22) was painted in the studio, although no evidence confirms it. The following year the rock was used as a motif in the painting *View from Stugunøset* (Nasjonalmuseet, Oslo) (Bang 1987, no. 1129).

9 T. Gunnarsson, in *A Mirror of Nature: Nordic landscape painting, 1840–1910*, exh. cat., Statens Museum for Kunst, Copenhagen 2006, p. 69.

10 The English patron was a certain Mr Bracebridge of London, otherwise unidentified. See Bang 1987, no. 563.

11 Dahl wrote to a friend on 6 April 1841: 'A landscape must not only show a particular country or region, it must have the characteristic of the country and its nature, it must speak to the sensitive beholder in a poetic way – it must, so to speak, tell about the country's nature …' Quoted in Bang 1987, vol. 1, p. 251, no. 57.

12 On Friedrich's conception of landscape painting, see most recently W. Hofmann, *Caspar David Friedrich*, London and New York 2000, pp. 18–26.

13 On early Norwegian landscape painting and its relation to the Swiss tradition, see K. Ljøgodt, 'Wild Nature: Swiss and Norwegian Landscape Painting,' in *Den Ville Natur: Sveitsisk og Norsk Romantikk: Malerie fra Asbjørn Lunde samling*, New York, exh. cat., Tromsø 2007, pp. 149–154.

14 See T. Gunnarsson, *Nordic Landscape Painting in the Nineteenth Century*, New Haven and London 1998, figs. 73 and 74.

15 Gunnarsson 1998, p. 79.

16 Bang 1987, vol. 1, p. 51.

17 M.L. Bang, 'Joseph Anton's Koch's 'Lauterbrunnental' and Johan Christian Dahl' in *På Klassik Grund: The Thorvaldsen Museum Bulletin*, Copenhagen 1989, pp. 237–46 and 365.

18 Bang 1987, vol. 1, p. 123.

19 The two paintings are *The Wreck* (V&A 1555–1869) and *Vessel in the Moonlight* (V&A 1579–1869).

20 Gunnarsson 2006, p. 106.

21 Gunnarsson 1998, p. 36.

22 On Fearnley's peripatetic career, see E. Haverkamp's insightful essay in *Nature's Way: Romantic Landscapes from Norway: Oil studies, watercolours and drawings by Johan Christian Dahl (1788–1857) and Thomas Fearnley (1802–42)*, Whitworth Art Gallery, University of Manchester, and Fitzwilliam Museum, Cambridge, 1993, pp. 22–6.

23 On Balke's trip to the North Cape, see P. Kvaerne and M. Malmanger, eds., *Un peintre norvégien au Louvre : Peder Balke (1804–1887) et son temps*, Oslo 2006, p. 11.

24 The Louvre sketches, rediscovered relatively recently but now elegantly displayed, are illustrated in Kvaerne and Malmanger 2006.

25 Quoted in P.G. Berman, 'Making Family Values: Narratives of Kinship and Peasant Life in Norwegian Nationalism,' in M. Facos and S.L. Hirsh, eds., *Art, Culture and National Identity in Fin-de-Siècle Europe*, Cambridge 2003, p. 210.

8 Knud Baade (1808–1879)
Scene from the Era of Norwegian Sagas, 1850
Oil on canvas · 87.6 × 119.4 cm

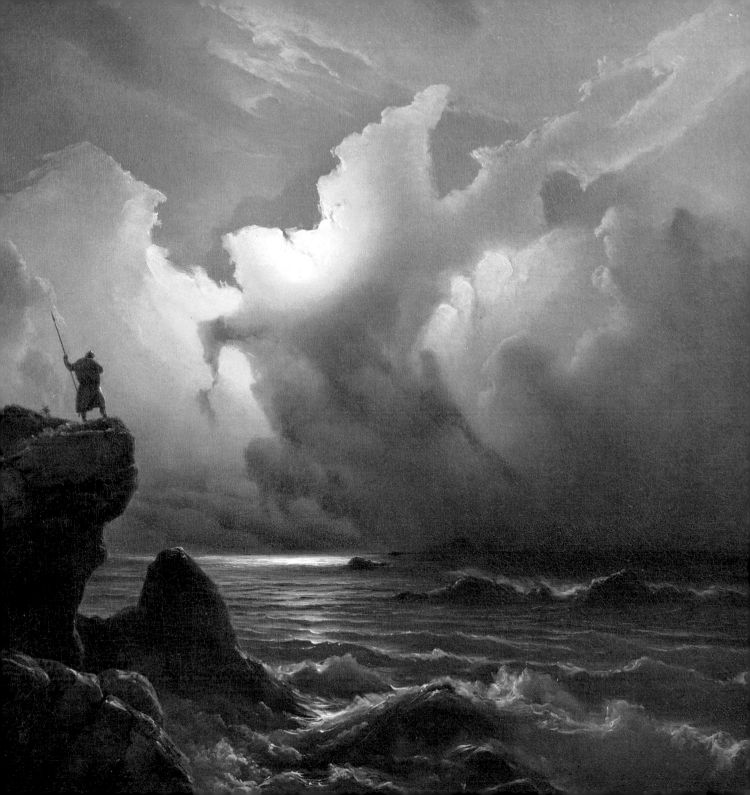

9 Knud Baade (1808–1879)
Peasant's Hut, 1861
Oil on canvas · 34 × 47 cm

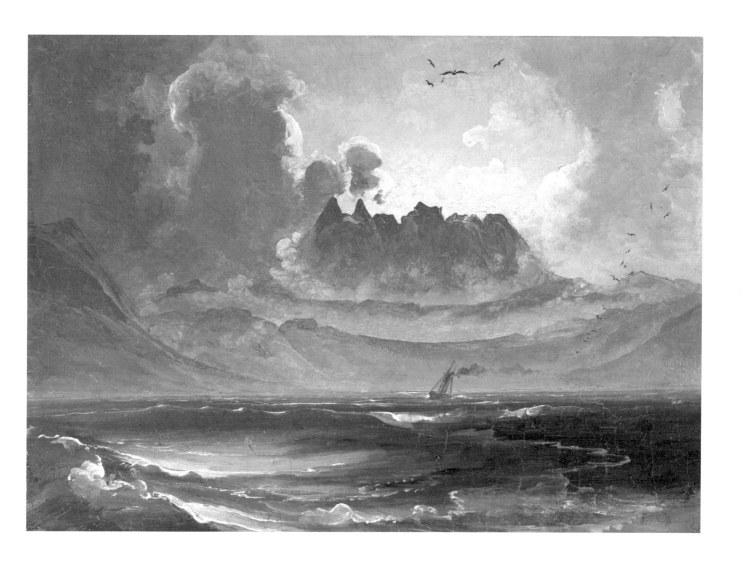

10 Peder Balke (1804–1887)
The Mountain Range 'Trolltindene', about 1845
Oil on canvas · 30.8 × 41.9 cm

11 Peder Balke (1804–1887)
Moonlit View of Stockholm, about 1850

Oil on canvas · 67.3 × 100.3 cm

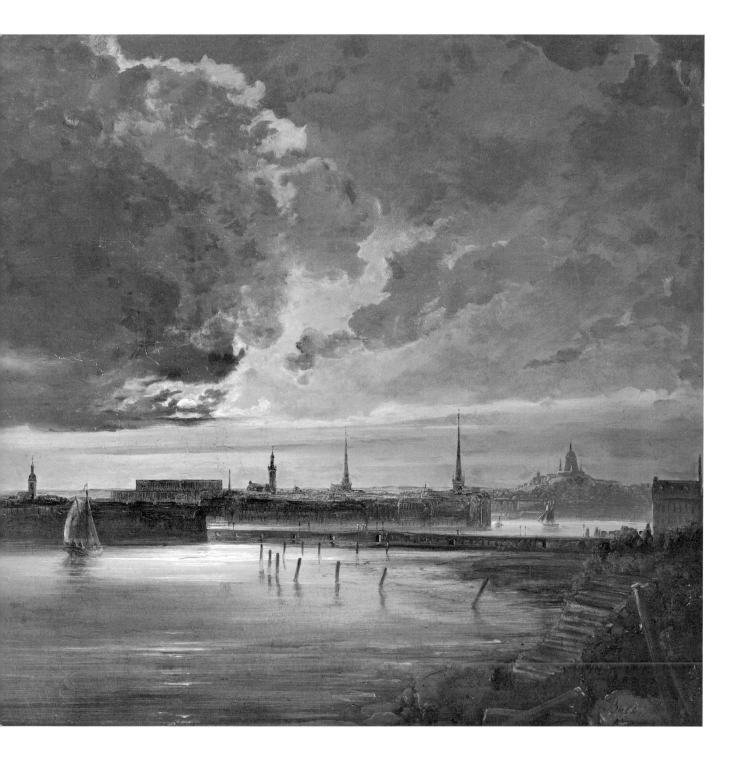

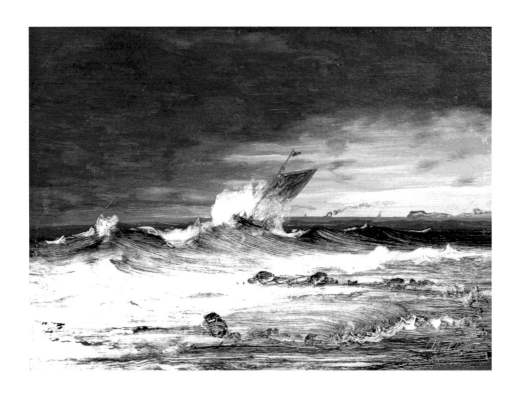

12 Peder Balke (1804–1887)
Seascape, about 1860

Oil on canvas · 16.8 × 23.2 cm

13 Peder Balke (1804–1887)
Landscape from Finnmark, about 1860

Oil on canvas · 34.9 × 52 cm

14 Johan Christian Dahl (1788–1857)
Grotto near Naples, 1821

Oil on paper · 27 × 43 cm

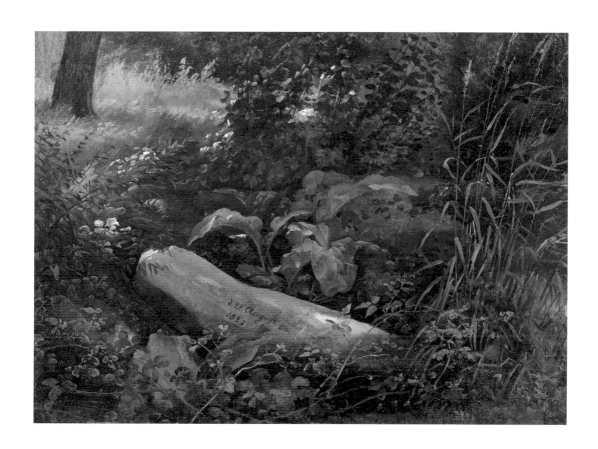

15 Johan Christian Dahl (1788–1857)
The Grosser Garten, Dresden, 21 August 1822

Oil on canvas · 25 × 34.5 cm

16 Johan Christian Dahl (1788–1857)
Chalk Pit near Maxen, 1835

Oil on canvas · 32.4 × 37.2 cm

17 Johan Christian Dahl (1788–1857)
Fjord Landscape with Menhir, 1837

Oil on canvas · 18 × 26 cm

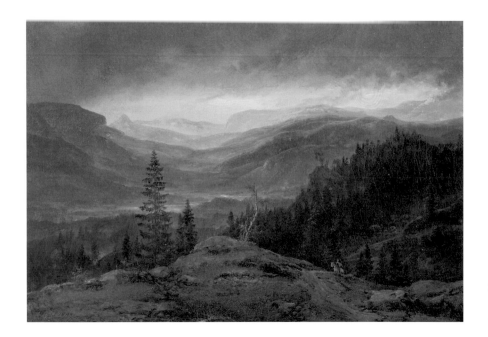

18 Johan Christian Dahl (1788–1857)
View over Hallingdal, 1844

Oil on canvas · 24.1 × 36.5 cm

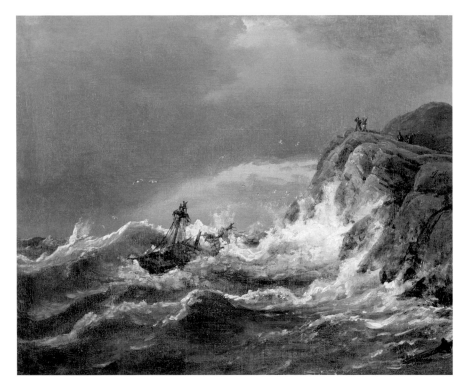

19 Johan Christian Dahl (1788–1857)
Shipwreck on the Coast between Larvik and Frederksvern, 1847

Oil on canvas · 25.7 × 32.4 cm

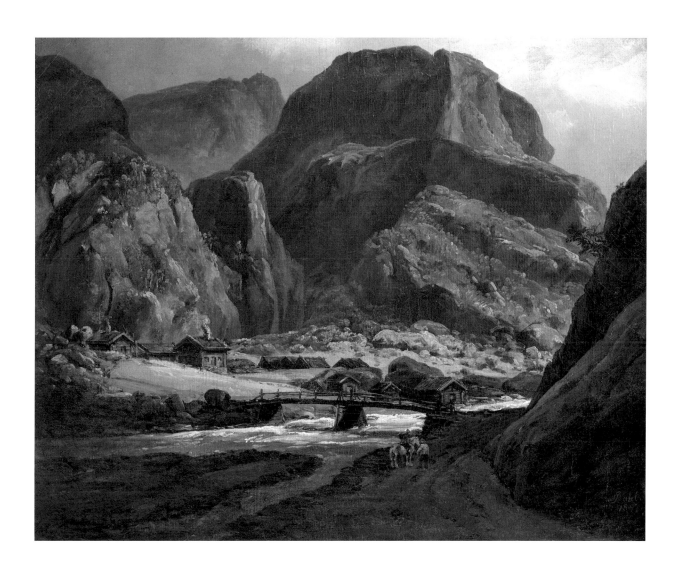

20 Johan Christian Dahl (1788–1857)
View of Naerodalen, 1847

Oil on canvas · 26 × 32 cm

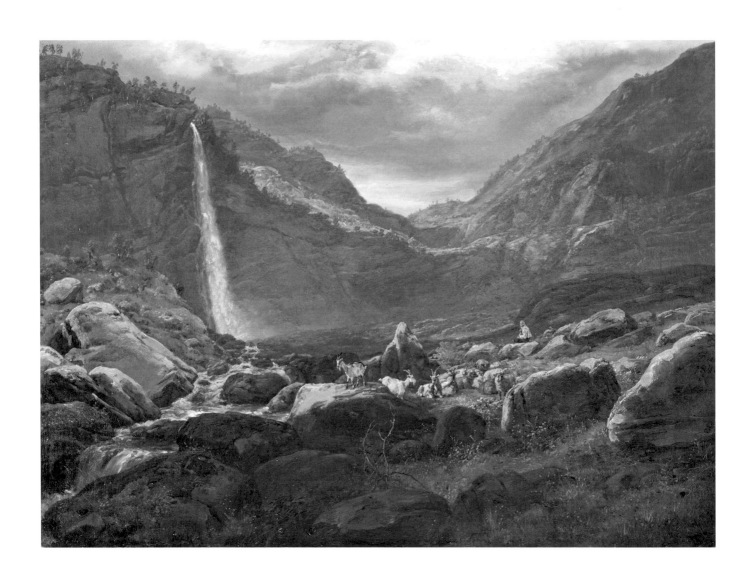

21 Johan Christian Dahl (1788–1857)
View of the Feigumfoss in Lysterfjord, 1848
Oil on canvas · 42 × 57.7 cm

22 Johan Christian Dahl (1788–1857)
Study of a Rock from Nystuen on Filefjell, 27 August 1850

Oil on paper · 36 × 46 cm

23 Johan Christian Dahl (1788–1857)
Mountain Farm, 27 May 1854

Oil on canvas · 33 × 48 cm

24 Thomas Fearnley (1802–1842)
Arco Naturale, Capri, before 1833

Oil on canvas · 40.3 × 51.1 cm

25 Thomas Fearnley (1802–1842)
View of Palermo and Monte Pellegrino,
21 June 1833

Oil on paper · 32.3 × 52 cm

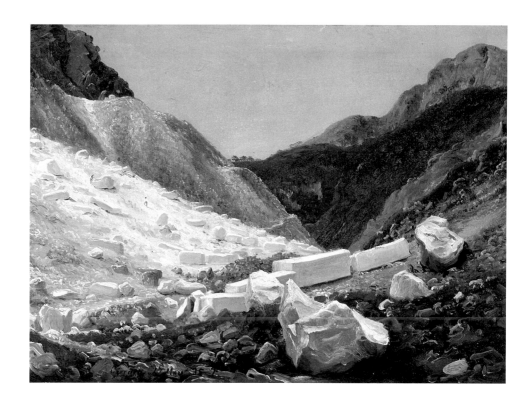

26 Thomas Fearnley (1802–1842)
At Carrara, 27 May 1835

Oil on paper, laid down on panel
28 × 38 cm

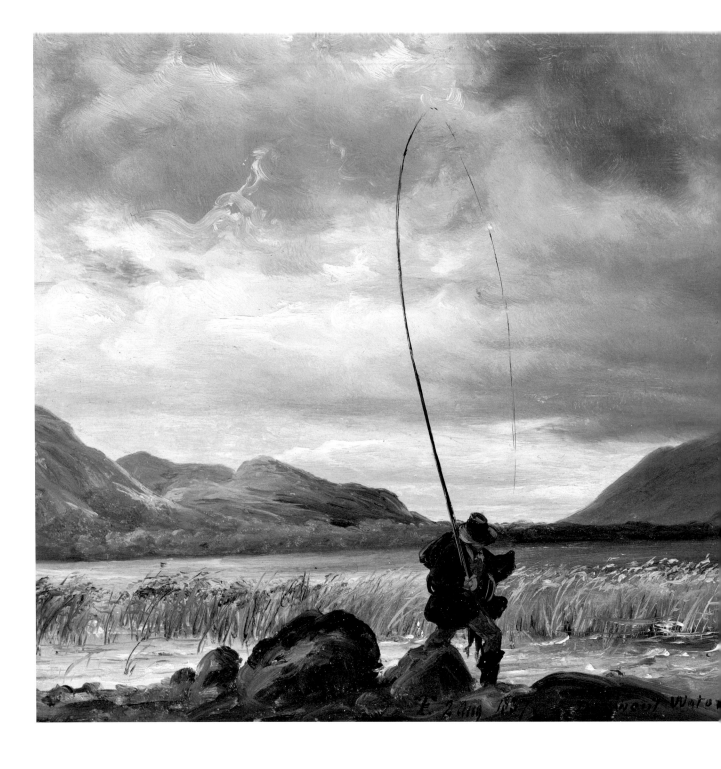

27 Thomas Fearnley (1802–1842)
Fisherman at Derwentwater, 2 August 1837
Oil on paper on panel · 25.4 × 37.8 cm

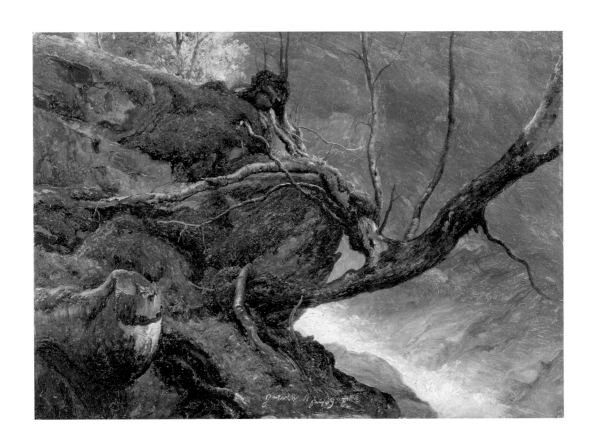

28 Thomas Fearnley (1802–1842)
Tree Study, by a Stream, Granvin, 11 July 1839

Oil on panel · 27.9 × 38.9 cm

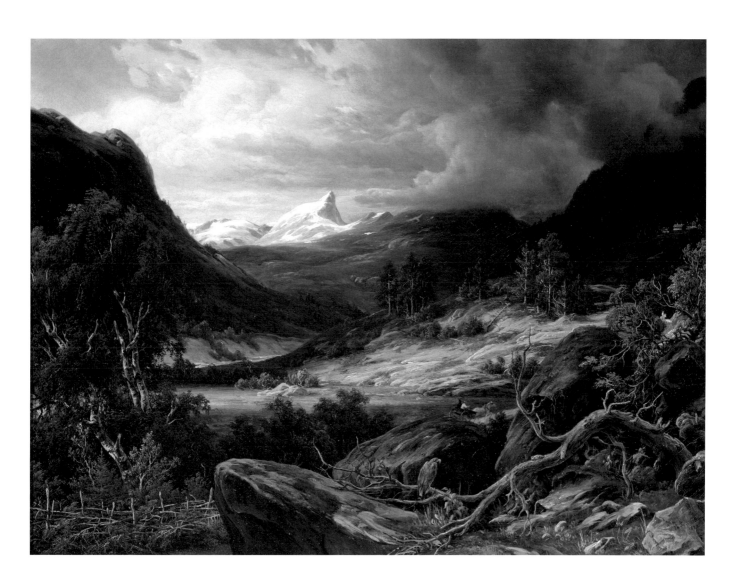

29 Thomas Fearnley (1802–1842)
View over Romsdal with Romsdalshorn in the Background, 1837
Oil on canvas · 45.7 × 61.3 cm

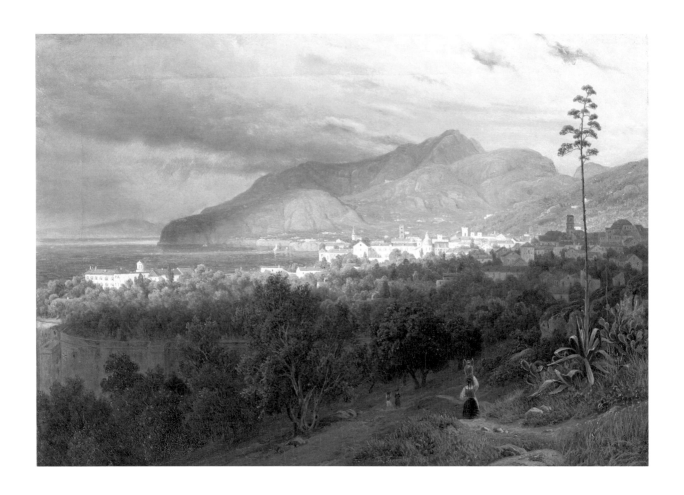

30 Thomas Fearnley (1802–1842)
Sorrento, 1840

Oil on canvas · 38.5 × 55 cm

The Discovery of the Swiss Alps

Sarah Herring

Imagine the variety, the grandeur, the beauty of a thousand stunning vistas; the pleasure of seeing all around you nothing but entirely new objects, strange birds, bizarre and unknown plants, of observing in a way an altogether different nature, and finding oneself in a new world.[1]

'Grandeur', 'beauty' and 'stunning'; during the eighteenth century these were new words for describing the Alps, for these mountains, hitherto considered as enemies, became during the Age of the Enlightenment objects of awe, wonder and study.[2] And these lines, written by Saint-Preux, one of the lovers in Jean-Jacques Rousseau's *Julie or The New Héloïse. Letters of Two Lovers who live in a small town at the foot of the Alps* (1761), encapsulate the themes of supernatural beauty and otherworldliness which began to permeate writings on the mountains of this period. Of vital importance too was the eighteenth century's fascination with science. Rousseau refers to the unknown species of plants and birds to be found in these inhospitable terrains, but these were already falling

under the scrutiny of a new breed of scientists. One such man, a pioneer of mountain research, was the Swiss naturalist and glaciologist Horace Bénédict de Saussure (1740–1799), who uncovered much not only in the fields of botany and geology, but also in the very topography of the Alps, thereby opening them up for further explorers. An indefatigable climber (ascending Mont Blanc in 1787), he describes seven of his Alpine expeditions in his *Travels in the Alps*, published in four volumes over the period 1779–96. It has been written that it was through Saussure that the Alps 'won for themselves a place, grudgingly yielded at first, on men's lips as "Beautiful Horrors", and then came to be hailed by poets as the Palaces of Nature, and accepted by the European public as the Playground of Europe'.[3] At this period scientific research went hand in hand with both literature and the visual arts. Saussure himself was much influenced by the botanist, poet and physician Albrecht von Haller (1708–1777), whose polymathy was typical of the time. Haller had undertaken his first Alpine trip in 1728 to collect botanical

54

specimens, a lifetime's work (with which he was helped by Saussure), culminating in 1768 with his inventory of Swiss flora. Also known as 'the Bard of the Alps', in 1732 he published his poem *The Alps* which, as with Rousseau's writings, contributed to the new craze for the mountains. The scientists could also be said to have given stimulus to the development of visual images of the Alps at this period. Saussure's *Travels* was illustrated with engravings after the work of artists such as Marc-Théodore Bourrit (1739–1819) and François Jallabert (1740–1798) [fig. 10]. But these were relatively minor figures compared with Caspar Wolf (1735–1783), considered among the first of the great Swiss landscapists, who was commissioned to provide paintings for *Remarkable Views of the Swiss Mountains* (1776), published by Haller's friend the Berne publisher Abraham Wagner (1734–1782) [fig. 11]. Wolf's own scientific interests were stimulated by one of Haller's disciples, Jakob Samuel Wyttenbach (1748–1830, theologian, mineralogist, geologist, botanist, zoologist and glaciologist) who accompanied him on his sketching expeditions.

The fascination with the geology and botany of the Alps was accompanied by an interest in the people who lived on their slopes. Of the 49 stanzas making up Haller's poem *The Alps*, the first 31 concentrate on the life of the mountain dwellers, a life which was felt to be good and natural by virtue of being lived in close proximity to a nature of a higher order to that of the plains, and to which life in the towns could simply not be compared. It was felt that the pure atmosphere had a beneficial effect also on visitors, as experienced by Saint-Preux: 'It was there that, in the purity of the air where I found myself, I came to an understanding of the

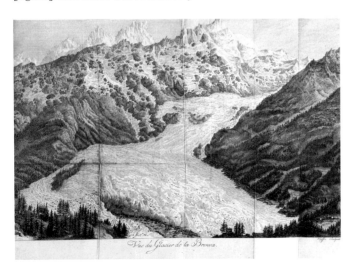

Vue du Glacier de la Brenva.

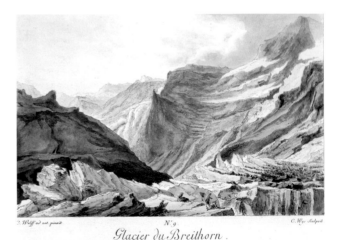

N.º 9

Glacier du Breithorn.

contre la Vallée de Lauterbroun.

Chute d'Eau apellée Staubbach dans la Vallée Louterbrunnen.
Definé par J. L. Aberli et gravé par M. Pfeninguer avec Privilège.

genuine cause of my change in humour, and of the return of that inner peace I for so long had lost.'[4] But additionally, the belief in nature as divine creation to which many, including artists such as Alexandre Calame, subscribed meant that the mountain villagers who – in contrast to city dwellers – lived in close contact with nature, were governed by nature's, and therefore divine laws.

Lastly there is another view of the Alps shaped by the Sublime, the English aesthetic concept that contemplation of immensity in nature can produce pleasure. After his Grand Tour of 1705 the English essayist, playwright and poet Joseph Addison (1672–1719) wrote of the 'agreeable kind of horror' elicited by the mountains.[5] These conflicting emotions of fear and attraction were later defined in largely physiological terms by Edmund Burke (1729–1797) in his *Philosophical Enquiry into the Origin of our Ideas of the Sublime and Beautiful* (1757). Although Burke was to oppose the aesthetic concepts of 'beauty' and the 'sublime', the perception that the Alps could be both beautiful and terrible pervades the art and literature of the period, as illustrated by Saussure, who talked of 'the terrible beauties of the rocks and the ice', and the evaluation of Wolf by Karl Gottlob Küttner in 1786: 'Wolf is a painter of the lofty, gentle, yet terrifying beauty of Switzerland'.[6]

The rise in popularity of Swiss scenery brought about by these changes in attitude resulted in a vast influx of tourists, who were catered for by a plethora of scenes of famous spectacles similar to those published in Saussure's *Travels,* mainly by what were essentially jobbing view painters, which were turned into coloured engravings, the precursors of the picture postcard [fig. 12].[7] However, towards the middle of the nineteenth century, these tourist-driven views developed into magnificent Romantic interpretations, a transformation which can to a large degree be explained by a rise of specifically Swiss culture throughout the period.[8] From the second half of the eighteenth century Switzerland was increasingly conscious of its identity as a confederacy, built up of a series of small states known as 'cantons', which had developed from the end of the thirteenth century. Although revolution in 1798 resulted in the Helvetic Republic, the confederacy was re-established in 1815, and after a civil war in 1848 the Federal Swiss Constitution was created. New societies formed, such as La Société Helvétique in 1761, founded to promote friendship and unity among the confederacies. It was also during this period that many artistic and cultural institutions were

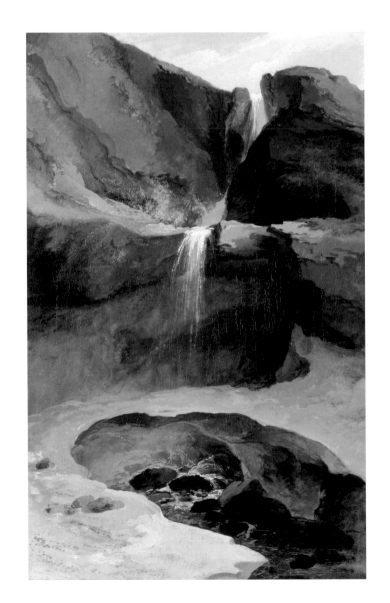

56 founded, such as the Société Suisse des Beaux-Arts in 1806.[9] Competitions for historical and national monuments were instituted, and from the middle of the nineteenth century travelling exhibitions, 'Tournus', were organised, which afforded opportunities for Swiss artists to exhibit and sell their work. And it was hoped that the development of a grand tradition of alpine painting would form the basis of a national school of Swiss painting.[10] In 1837 Rodolphe Töpffer, son of the landscape artist Adam Töpffer (1766–1847), while deploring the tourist view trade, called for a Swiss school of painting worthy of the country's magnificent scenery,[11] which a number of artists can be credited with bringing about.[12]

Long before the advent of the Romantics the aforementioned Wolf stood out from the view painters in both his determination to penetrate deeply into the mountains and his combination of topographical accuracy with naturalistic effects. On his excursions undertaken for Wagner's enterprise he was instructed in such subjects as glaciology and geology. His concern for accuracy was such

that he would often take a painting back to the same spot for necessary corrections. Wolf's personal interests lay in the depiction of rocks, caves and water in all its forms: lakes, waterfalls or glaciers. *The Geltenbach Falls in the Lauenen Valley with an Ice Bridge,* cat. 50), a study painted in the western Bernese Alps for a larger studio painting [fig. 13], includes all these elements: ice, the fall of water and eroded rocks, the latter dominating the picture surface to such a degree that only a small amount of sky is glimpsed at the top. In the foreground a spring thaw has transformed the solid ice into a delicate ice bridge, whose elegant serpentine form contrasts with the formidable rock formations behind, out of which the waterfall surges.

As a contrast to the high-Alp themes of Caspar Wolf, Adam Töpffer specialised in depicting the life of the villages around Geneva [fig. 14]. He also made oil sketches of the local scenery which he used, often juxtaposed, as backgrounds for those studio compositions. His *plein-air* studies and pure landscapes composed from sketches were intimate and atmospheric

scenes which anticipated the work of the Barbizon painters in France (the loose-knit group of artists who from the 1830s gathered in the Forest of Fontainebleau to paint studies from nature). One such work is *Study of Rocky Lakeside Landscape (possibly Lake Geneva)* [cat. 49]. Primarily a study of rock formations surmounted by pine trees, it is detailed and meticulous, yet at the same time suggestive of the quiet grey light of the day.

François Diday (1802–1877), who studied landscape with Adam Töpffer, can be considered as one of the first of the Romantics, whose style combined keen observation of atmosphere with topographical accuracy. Like Töpffer he made studies in the open air, but his studio work is characterised by a high degree of finish. *The Wetterhorn with Upper and Lower Grindelwald Glacier* [cat. 5] is a quintessential Romantic alpine landscape, with the mountain

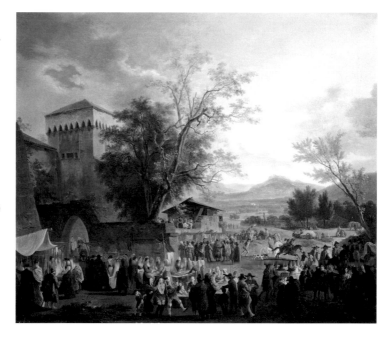

mysteriously shrouded in clouds rolling in from the left, dwarfing both the dramatically sunlit middle ground of isolated chalet and cattle, and the brooding foreground.

Diday ran a flourishing studio, but among his many pupils one name stands out: that of Alexandre Calame (1810–1864), who, despite his modest beginnings, blindness in one eye, and a limp, became one of the foremost figure of Swiss landscape painting in the nineteenth century. Early employment included colouring engraved landscapes for tourists and working for the banker Jacques Amédée Diodati, who made it possible for him to study with Diday. His painting owes much to the work of the Dutch seventeenth-century landscapists, such as Jacob van Ruisdael (1628/9?–1682), in its portrayal of mountains, dense fir forests and raging torrents. While he spent his summers working in the open air, in his studio works Calame, like Diday, adhered to the academic principles of finish and composition, which at first sight appear to sit at odds with the Romantic sensitivity of his scenes. But this latter quality can be seen

as a consequence of his belief in the divinity of nature. He also considered his work as a homage to God: 'I would be pleased if my portraits of the great Alps made people say that the Heavens spoke of the Glory of God, and that their extent made known the work of His hands. The Creator lives in me, and since everything is intimately linked in our nature, my work contributes to the homage rendered by my soul to the Author of all beauty and truth.'[13]

The theme of torrents was central to Calame's work, with many of his paintings depicting the largest river in Switzerland, the Aare, which he sketched during his excursions in the Bernese Oberland. *Mountain Torrent before a Storm (The Aare River, Haslital)* [cat. 2] underlines the inhospitable qualities of the landscape in which the unleashed forces of nature predominate: the cloud building up on the left, the trees buffeted by the wind, and the light breaking through the clouds at the centre echoed in the white foam of the torrent hurtling its way towards the left corner.

During his walks around Lake Lucerne from the 1850s onwards,

Calame regularly produced drawings and painted sketches. *Cliffs of Seelisberg, Lake Lucerne* [cat. 38] and *Lake Lucerne, Uri-Rotstock* [cat. 39], which shows the same site from north to south, are examples of such studies, with, however, a crispness of outline and flatness of colour which demonstrate the artist's interest in order and precision. This graphic approach to the rocks shows itself to an even greater degree in *The River Lutschine near Lauterbrunnen* [cat. 45]. The high viewpoint taken in both the Lake Lucerne paintings heightens the sense of the sheer drop into the lake. The crystal clear water is rendered in greens and turquoise, darkened where the jagged peaks throw their shadows. Both pictures are pervaded with a sense of nature's grandeur, and both portray a harsh, majestic environment untouched by man. By contrast, in *Chalets at Rigi* [cat. 42], man's contribution to the landscape equals decay and destitution; the ruined and abandoned chalets, seen in deep shadow, are set against the light emanating from behind the mountains. These, rendered in misty blues, contrast with the

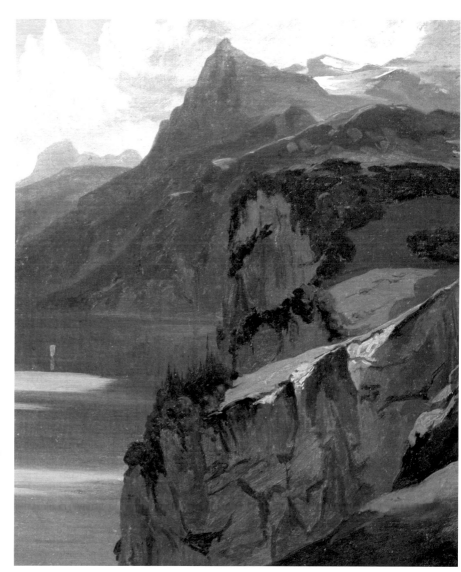

starkly painted structures in the foreground. Calame also uses the device of a heavily shadowed foreground in *The Mythen* [cat. 43], where the mountains, set in the middle ground, are touched by the glowing setting sun.

Both Diday and Calame worked primarily on commission for an international clientele (*Mountain Torrent before a Storm* was painted for the influential Russian Yusupovs). In Calame's case the commissions were all recorded in his unpublished account book, *Catalogue of my Work in Oil and Watercolour,* which reveals a repertoire of subjects regularly chosen by his patrons: mountains, waterfalls, glaciers, fir trees, snow and weather of every description, indicating that such commissions extended beyond pictures of particular landmarks, to broader, more generic views of Swiss scenery.[14] Victims of both their own success and the popularity of mountain views, Diday and Calame were forced endlessly to repeat studio compositions for demanding clients. Perhaps it was for this reason that it was his *plein-air* studies which Diday held in highest regard at the end of his life: 'I consider

the most interesting part of my work as an artist.'[15] As for Calame, during his visits to Paris in both 1842 and 1855 he encountered the works of the Barbizon painters, and although he was critical of their exhibited landscapes, which he found rough and incomplete when viewed close-up, their influence shows in his own studies from the 1850s and 1860s. *Beech Grove, Rocky Foreground* [cat. 32] is reminiscent of their studies of rocks in the forest of Fontainebleau. A painterly exploration of the surface textures of rocks and bark, of mosses and lichens, it is an intimate corner of nature with nothing of the heroic or dramatic. It is this very lack of sublimity which signals an important new direction for Calame at this period.

The Barbizon painters were also of importance for Johann Gottfried Steffan (1815–1905) and Robert Zünd (1827–1909). While, as with Calame and Diday, both Steffan and Zünd produced views of the Alps, and maintained the distinction between plein-air studies and studio works, they also painted direct views of ordinary nature. Steffan's *The Hintersee, near Berchtesgaden* [cat. 48] contrasts the striking forms of the driftwood and rocks with the feathery grasses growing along the shore. Like Calame's *Beech Grove, Rocky Foreground*, it is a naturalistic study of an unremarkable scene, brought alive through colour and brushwork.

When Zünd painted out of doors, he concerned himself not with capturing fleeting effects, but with rendering the precise detail of nature, and many of his studies are highly finished. Gottfried Keller described his work as 'true ideal realistic landscape or realistic ideal landscape'… 'a clear and rounded motif comparable to a refined visionary image, a poem, and yet earth-bound to the last blade of grass'.[16] By contrast *Storm Study* [cat. 51] is painted in a broadly handled manner, yet introduces an element of deliberate invention in the figure buffeted against the weather hurrying his flock to the comparative shelter of the trees. The plight of man pitted against the forces of nature, the extraordinary contrasts of light and shade created by the shaft of sunlight breaking through the pitiless grey clouds, catching the tops of the trees and turning a patch of landscape into vivid green, the touch of red provided by the shepherd's cloak; all this suggests the work of Barbizon painters, notably Narcisse Diaz (1807–1876).

The story of landscape painting in Switzerland in the late eighteenth and nineteenth centuries is intimately bound up in its extraordinary scenery, with the mountains as tailor-made subject. But by the 1870s, the phenomenal appeal of the Alps resulted in a repetitiveness that echoed the mass views produced earlier in the century. With the example of both the Barbizon painters and earlier artists such as Töpffer, a shift away from extreme landscape ushered out the grand period of great Alpine views in favour of a more intimate nature.

1 'Imaginez la variété, la grandeur, la beauté de mille étonnants spectacles; le plaisir de ne voir autour de soi que des objets tout nouveaux, des oiseaux étranges, des plantes bizarres et inconnues, d'observer en quelque sorte une autre nature, et de se trouver dans un nouveau monde.' jean-Jacques Rousseau, *Julie ou La Nouvelle Héloise. Lettres de deux amants habitants d'une petite ville au pied des Alpes*, first published 1761, Classiques Garnier edition, Paris 1960, première partie, lettre XXIII, pp. 52–3. Translation, Philip Stewart and Jean Vaché, *The collected writings of Rousseau*, vol. 6, Hanover and London 1997, p. 65.

2 In a discussion both of the subject of Swiss landscape painting in the nineteenth century and of the paintings in the Lunde collection in particular the author refers the reader to A. de Andrés, *Alpine Views. Alexandre Calame and the Swiss Landscape*, exh. cat., Sterling and Francine Clark Art Institute, Williamstown 2006, and A. Aaserud and K. Ljøgodt, *Den Ville Natur. Sveitsisk og Norsk Romantikk Malerier fra Asbjøn Lundes samling, New York*, exh. cat., Nordnorsk Kunstmuseum, Tromsø, Bergen Kunstmuseum, Scandinavia House, New York 2007–8. The author is indebted to both of these in the writing of this essay.

3 D.W. Freshfield, *The Life of Horace-Bénédict de Saussure*, London 1920, pp. 22–3. See W. Hauptmann, *La Suisse Sublime vue par les peintres voyageurs 1770–1914*, exh. cat., Fondation Thyssen-Bornemisza, Lugano 1991, for a study of painters visiting from all over Europe.

4 'Ce fut là que je démêlai sensiblement dans la pureté de l'air ou je me trouvais la véritable cause du changement de mon humeur, et du retour de cette paix intérieure que j'avais perdue depuis si longtemps.' Rousseau 1761, pp. 51–2. Translation as before, p. 65.

5 J Addison, *Remarks on Several Parts of Italy, Etc*, London 1705, pp. 510–11. Bevis labels this reaction as an 'emotional oxymoron' which was to become standard. R. Bevis, *The Road to Egdon Heath. The Aesthetics of the Great in Nature*, Montreal and Kingston 1999, p. 45.

6 Saussure, *Voyages dans les Alpes*, quoted in C. Reichler, *La découverte des Alpes et la question du paysage*, Geneva 2002, p. 64. K.G. Küttner, *Briefe eines Sachsen aus der Schweiz an seinem Freund in Leipzig*, 3 vols, Leipzig 1785–6, II, p. 179, quoted in B. Wismer, 'Die Revision der Malerei aus dem Geist der Geologie. Zur Bergmalerei von Caspar Wolf', in A. Haldemann, S. Kunz, C. Reichler and B. Wismer, *Caspar Wolf – Gipfelstürmer zwischen Aufklärung und Romantik*, exh. cat., Museum Kunst Palast, Düsseldorf 2009–10, pp. 9–19 (11).

7 On these see, for example, M-L. Schaller, *Annäherung an der Natur. Schweizer Kleinmeister in Bern 1775–1800*, Bern 1990.

8 See C. Klemm, *Von Anker bis Zünd. Die Kunst im jungen Bundesstaat 1848–1900*, exh. cat., Kunsthaus Zürich and Musée d'art et d'histoire, Geneva 1998.

9 For a history of Swiss art institutions and exhibitions during the nineteenth century see particularly F. Deuchler, M. Roethlisberger and H.A. Lüthy, *La Peinture Suisse du moyen âge à l'aube du XXe siècle*, Geneva 1975, pp. 129ff.

10 R. Töpffer, 'Du touriste et l'artiste en Suisse, 1837', in *Mélanges*, Paris 1852, cited in de Andrés 2006, p. 20.

11 On this see A. de Andrés, *Westwind Zur Entdeckung des Lichts in der Schweizer Landschaftsmalerei des 19. Jahhunderts. Vent d'Ouest. La découverte de la lumière dans la peinture suisse de paysage au XIXe siècle*, exh. cat., Seedamm Kulturzentrum, Siftung Charles und Agnes Vögele, 2000 p. 26.

12 As acknowledged by Töpffer in an essay of 1843. R. Töpffer, 'Du paysage alpestre, 1843', in *Mélanges*, Paris 1852, cited in de Andrés 2006, p. 20.

13 In A. Schreiber-Fabre, *Alexandre Calame, peintre paysage, graveur et lithographe*, Lausanne 1934, p. 43.

14 *Catalogue de mes ouvrages à l'huile et à l'aquarelle*. Collection of the artist's family.

15 Quoted in D. Buyssens, 'Diday, François', in *Biographisches Lexikon der Schweizer Kunst*, Zurich 1998, I, pp. 261–2.

16 G. Keller, 'Ein bescheidenes Kunstreisen (A Modest Little Art Tour)', *Neue Zürcher Zeitung*, 23 March 1882, no. 82, quoted in P. Wegmann, *Caspar David Friedrich to Ferdinand Hodler: A Romantic Tradition. Nineteenth-Century Paintings and Drawings from the Oskar Reinhart Foundation, Winterthur*, exh. cat., Alte Nationalgalerie, Berlin, Los Angeles County Museum of Art, Metropolitan Museum of Art, New York, National Gallery, London, Musée d'Art et d'Histoire (Musée Rath), Geneva 1993–5, p. 180.

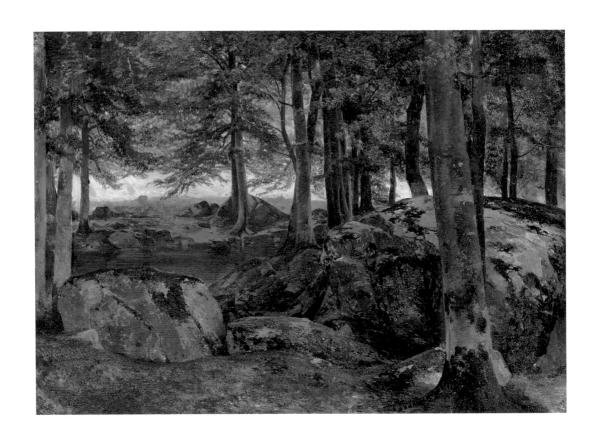

32 Alexandre Calame (1810–1864)
Beech Grove, Rocky Foreground, about 1850–5

Oil on canvas · 36 × 50.5 cm

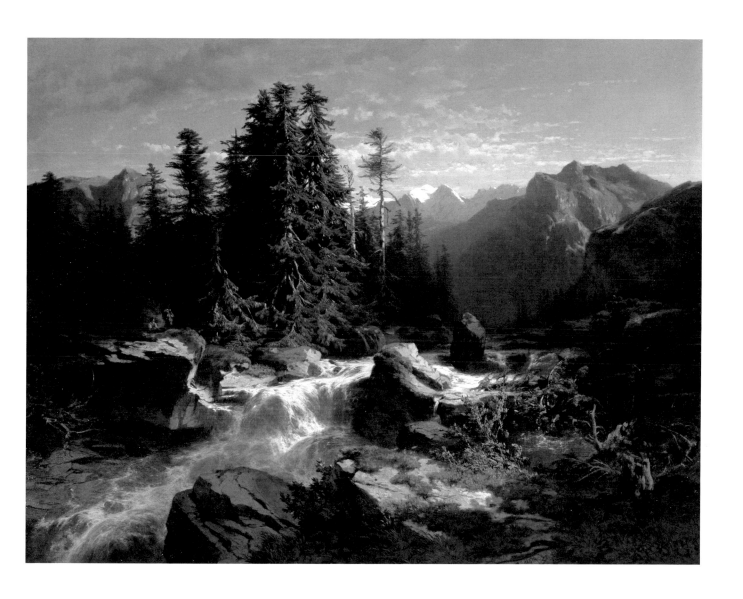

33 Alexandre Calame (1810–1864)
Torrent in the Alps, 1849

Oil on canvas · 57.8 × 76 cm

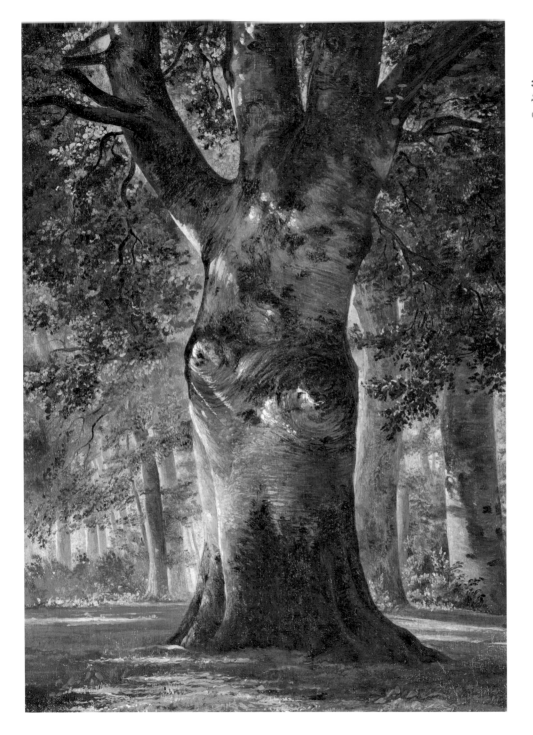

34 Alexandre Calame (1810–1864)
Stem of a Beech Tree, 1850–5
Oil on card · 45.5 × 33.5 cm

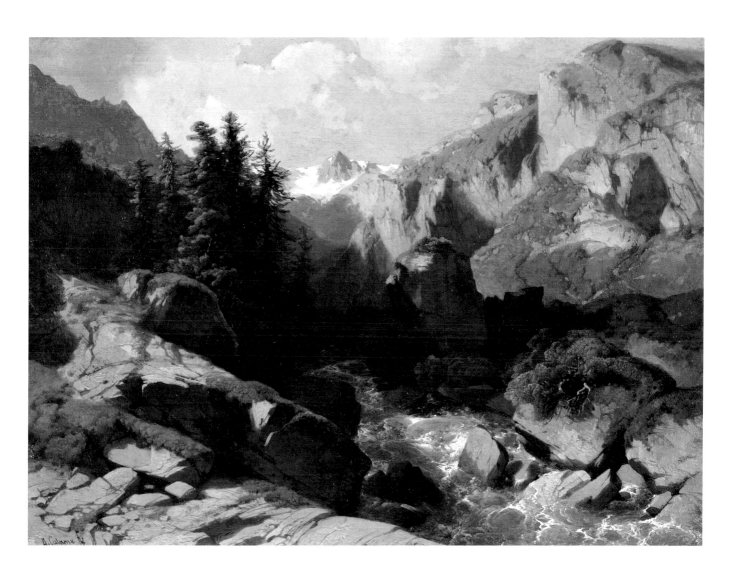

35 Alexandre Calame (1810–1864)
Mountain Torrent, about 1850–60

Oil on canvas · 28 × 37.5 cm

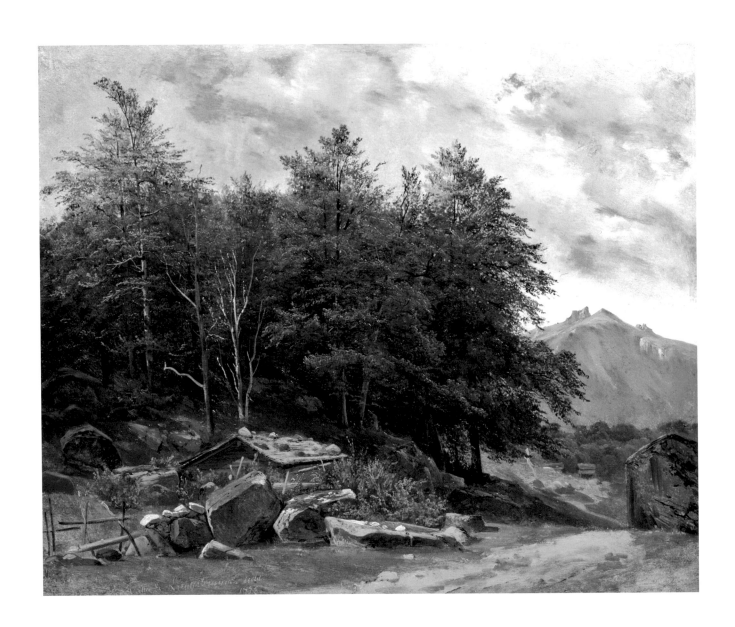

36 Alexandre Calame (1810–1864)
Valley of Lauterbrunnen, August 1856

Oil on paper, on canvas · 45.4 × 55.6 cm

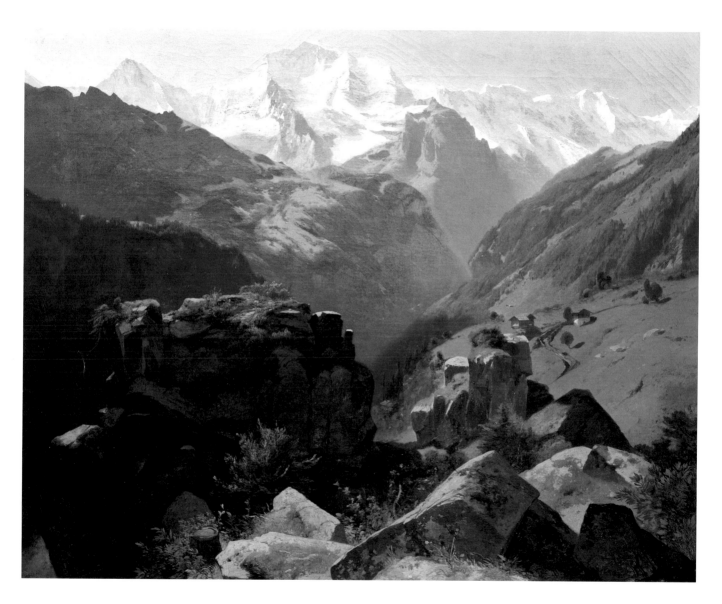

37 Alexandre Calame (1810–1864)
A View of the Jungfrau Massif seen from Above,
Interlaken, about 1854–60

Oil on canvas · 50 × 63 cm

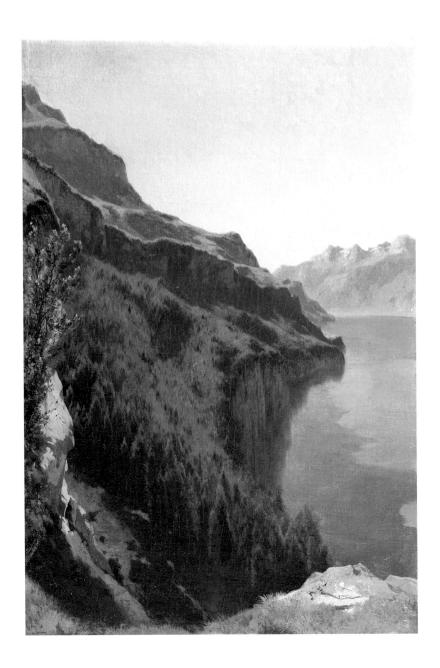

38 Alexandre Calame (1810–1864)
Cliffs of Seelisberg, Lake Lucerne, about 1861

Oil on canvas laid on cardboard · 38.4 × 26.4 cm

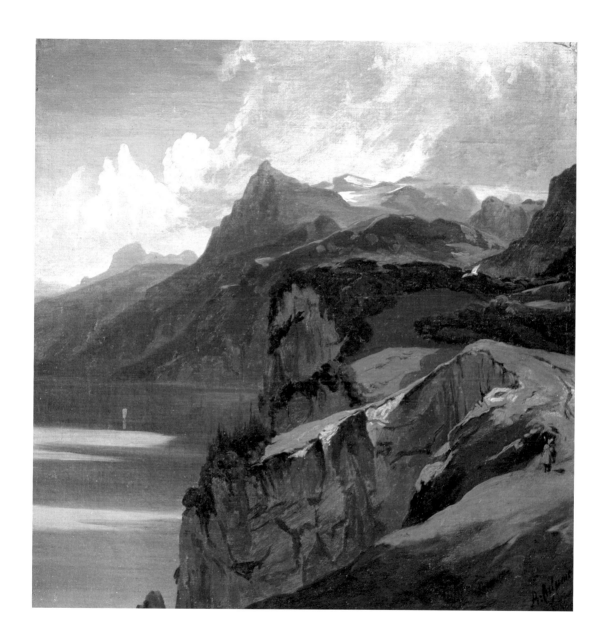

39 Alexandre Calame (1810–1864)
Lake Lucerne, Uri-Rostock, about 1857–61

Oil on canvas · 32.7 × 31.3 cm

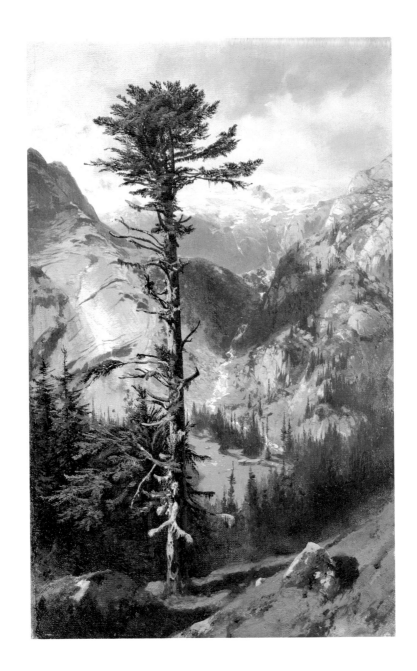

40 Alexandre Calame (1810–1864)
Rocky Path, 1860
Oil on paper, laid on board · 25 × 27.4 cm

41 Alexandre Calame (1810–1864)
At Handeck, about 1860

Oil on canvas · 39.4 × 24.5 cm

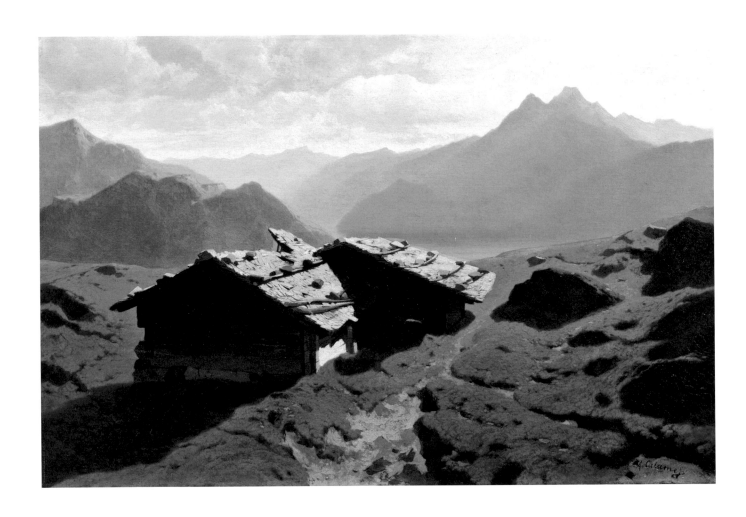

42 Alexandre Calame (1810–1864)
Chalets at Rigi, 1861

Oil on canvas · 40.6 × 62.2 cm

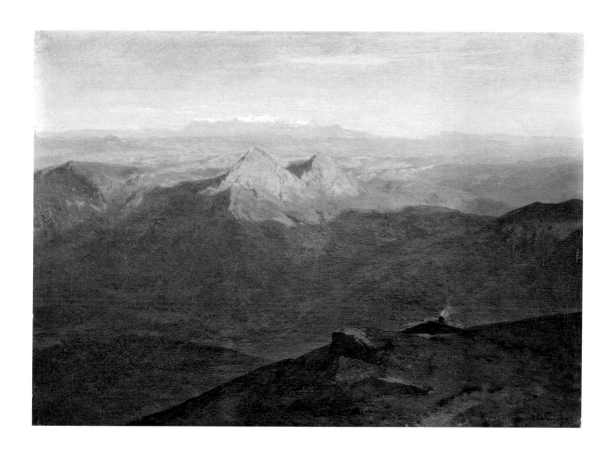

43 Alexandre Calame (1810–1864)
The Mythen, about 1861

Oil on canvas · 27 × 37.3 cm

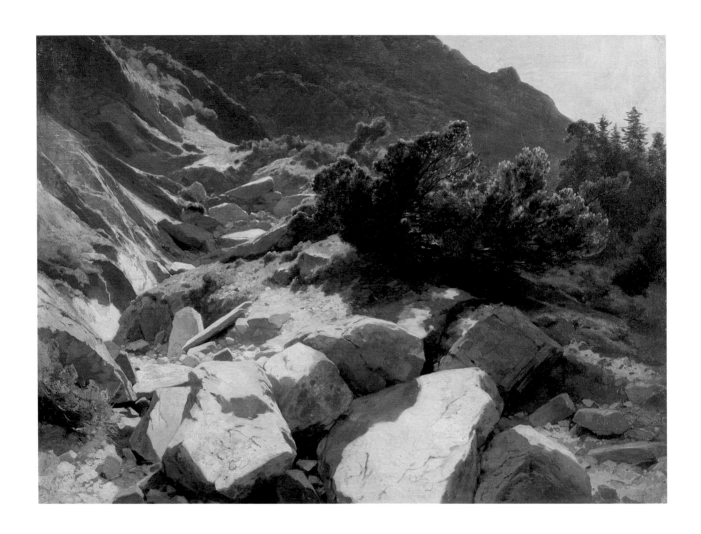

44 Alexandre Calame (1810–1864)
Riverbed at Rosenlaui, about 1862

Oil on canvas · 41 × 55.3 cm

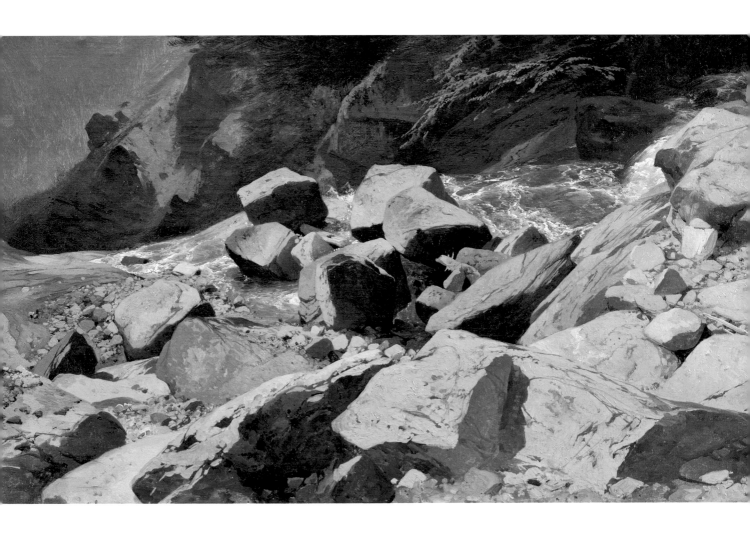

45 Alexandre Calame (1810–1864)
The River Lutschine near Lauterbrunnen, about 1862

Oil on canvas · 31.3 × 52.2 cm

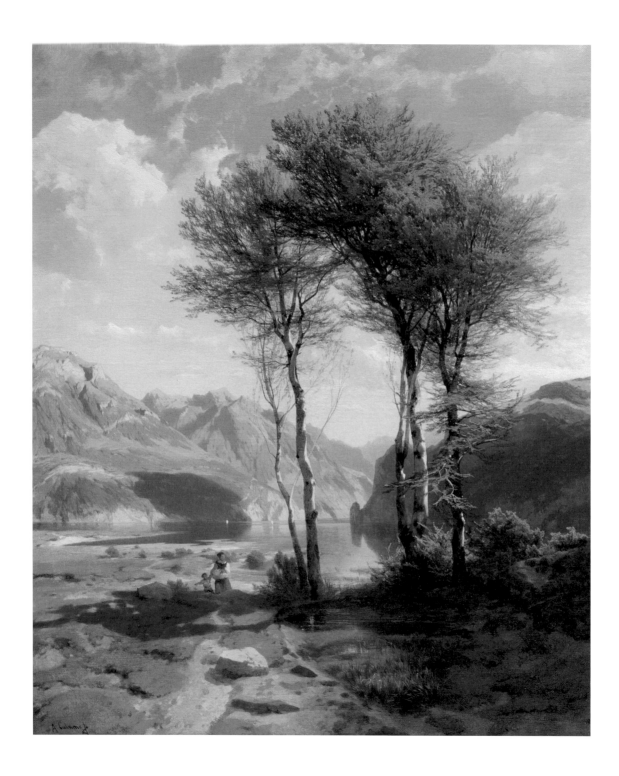

46 Alexandre Calame (1810–1864)
Souvenir of Lake Lucerne, 1862

Oil on canvas · 51.1 × 42.5 cm

47 Johann Gottfried Steffan (1815–1905)
Lake Brienz, 12 September 1865

Oil on canvas · 36.4 × 46 cm

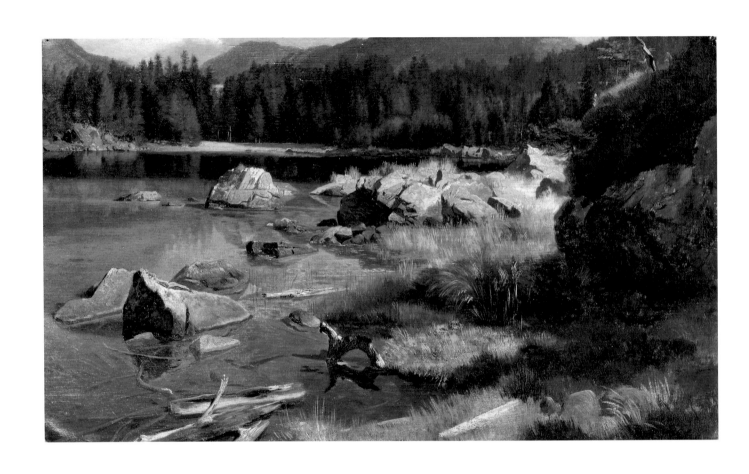

48 Johann Gottfried Steffan (1815–1905)
The Hintersee, near Berchtesgaden, 1871

Oil on canvas · 26 × 46.4 cm

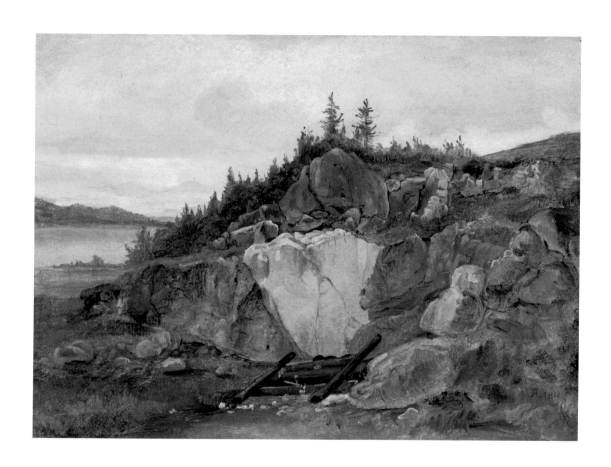

49 Adam Wolfgang Töpffer (1766–1847)
Study of Rocky Lakeside Landscape (possibly Lake Geneva), 1812

Oil on cardboard · 21 × 29.2 cm

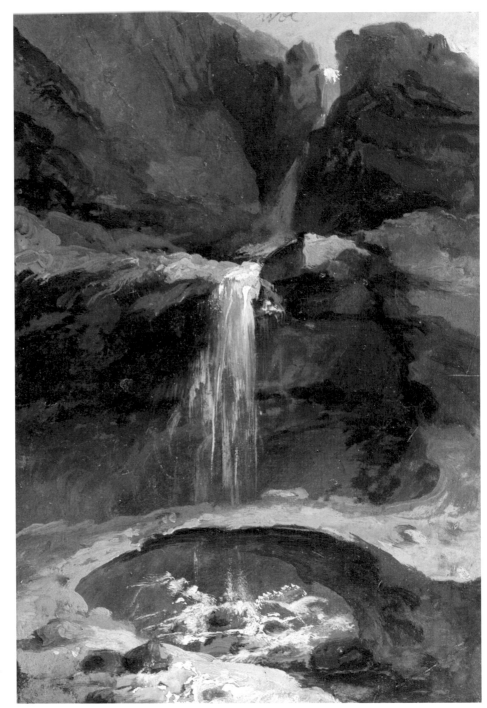

50 Caspar Wolf (1735–1783)
*The Geltenbach Falls in the
Lauenen Valley with an Ice Bridge,*
about 1778

Oil on cardboard · 29.1 × 20.3 cm

Artist Biographies

Christopher Riopelle and Sarah Herring

Knud Baade 1808–1879

Knud Baade was raised in Bergen, first learned art there and in 1827 moved to Copenhagen to study at the Royal Danish Academy of Fine Arts. Returning to Christiania (later known as Oslo) and then, following the movements of his family, to more remote communities in Norway, he worked as a portrait painter while developing an interest in landscape painting. In 1837, struck by the young man's talent, Johan Christian Dahl (see overleaf) persuaded Baade to come to Dresden. He studied there for three years and was exposed to the art of Caspar David Friedrich (1774–1840), a formative influence on his Romantic view of landscape. Eye disease caused him to return to Norway, but from 1846 he moved south again to build a career in Munich. He also painted in the Tyrol and Switzerland – the Swiss painter, Johann Gottfried Steffan (see page 86) may have been a friend – and established an impressive international reputation, now largely forgotten, for coastal scenes full of exaggerated moonlight and storm effects. He died in Munich aged 71. CR

K. Ljøgodt, 'Knud Baade als Historienmaler', *Münchner Jahrbuch der bildenden Kunst*, Dritte Folge Band LIX 2008, pp. 289–99.

Peder Balke 1804–1887

Born poor on the remote northern island of Helgøya, Peder Balke studied decorative painting in Christiania for two years from 1827. Determined to become an artist, in 1829 he transferred to Stockholm and the Royal Swedish Academy of Arts. His early landscape paintings, however, rise little above academic convention. Drawn to the landscape of Norway, Balke walked across much of its lower regions and, decisively, in 1832 travelled by ship to the North Cape, a rugged and largely inaccessible area of the country. There he found bleak and original landscape motifs which allowed him to define his highly individual painting style. He continued to explore these motifs in increasingly austere images throughout his career. In 1835–6 and again in 1843–4 he travelled to Dresden, where he met the grand old man of Norwegian painting, Johan Christian Dahl (see overleaf), later painting with him in Norway. In 1845 he headed to London and to Paris, where he received a major commission from King Louis Philippe (1773–1850) for northern Norwegian scenes. The 1848 Revolution and the ousting of the king saw the commission abandoned, although today 28 sketches for it remain in the Louvre. By 1850 Balke was back in Christiania, although his artistic career was foundering and he devoted

more time to politics and property. By about 1860 his paintings – for the most part small, improvisational oils on panel – were made primarily for his own amusement. He died in 1887, his art forgotten. A revival of interest began in Norway as early as 1914, but failed to spread beyond its borders. The current keen international fascination in Balke is of more recent date and intensity. CR

P. Kvaerne and M. Malmanger (eds.), *Un peintre norvégien au Louvre : Peder Balke (1804–1887) et son temps*, Oslo 2006.

Peder Balke: Ein Pionier der Moderne, exh. cat., Kunsthalle, Krems, and Ordrupgaard, Copenhagen, 2008–2009.

Alexandre Calame 1810–1864

The son of a marble carver, Alexandre Calame spent his childhood in Vevey. In 1820 he lost the sight in one eye as the result of an accident while playing. His family moved to Geneva in 1824; two years later his father died, forcing Alexandre to support the family by working in a bank and, more significantly for his future career, colouring engraved landscapes for tourists.

From 1829 he studied under François Diday (see opposite), and in 1834 he opened his own studio. In 1835 he made his first trip to study the Bernese Oberland; from this time on he would spend his summers

drawing and painting, sometimes with friends and pupils, in the Swiss mountains, especially those of the Bernese Oberland and central Switzerland, using his studies from nature in his studio compositions. He also made trips in Europe, visiting Paris in 1837, the Netherlands and Germany in 1838, Italy in 1844 and London in 1850.

Calame's studio paintings were mostly produced on commission for middle-class and aristocratic clients who required a standard repertoire of Swiss motifs: glaciers, waterfalls, lakes, mountains, trees and snow. At the same time these grand alpine landscapes reflect Calame's Calvinist belief in the divinity of nature.

Enjoying an international reputation during his lifetime, Calame was elected to eight national academies. His *View of the Valley of Ansasca* (Assemblée Nationale, Paris), exhibited at the Paris Salon of 1841, was purchased by King Louis-Philippe (1773–1850), and in 1842 he received the Croix de la Légion d'honneur. In 1855 he exhibited at the Exposition Universelle in Paris, where Napoleon III (1808–1873) purchased one of his paintings, *Lake of the Four Cantons* (Fondation Abegg, Riggisberg). SH

V. Anker, *Alexandre Calame. Vie et Oeuvre. Catalogue raisonné de l'oeuvre peint*, Fribourg 1987.

V. Anker, *Alexandre Calame (1810–1864), dessins, catalogue raisonné*, Wabern-Berne 2000

Johan Christian Dahl 1788–1857

The leading Norwegian artist of his day, Johan Christian Dahl was also one of the most important landscape painters of the Romantic era. He was born in Bergen, where his artistic talent was recognised early and given financial support, and in 1811 he was sent to Copenhagen to study at the Academy there. Early on, he determined that Norway would be a central subject of his art – not necessarily an obvious choice – and set about learning landscape painting from both his contemporaries and the Dutch Old Masters. He also learned to make landscape oil sketches in nature which he would then use to work up elaborate 'finished' paintings in the studio. This method of working remained central to his practice throughout his career. Dahl relocated to Dresden in 1818, where he befriended Caspar David Friedrich (1774–1840), thus placing himself at the centre of the Romantic landscape tradition. Travels in Italy followed in 1820 and 1821, but he returned to Dresden to make his lifelong career there; indeed, from 1824 he was a professor at the Academy there. From 1826, however, Dahl repeatedly returned to Norway, where he studied the ancient

history and archaeology of his homeland and gathered landscape motifs. He visited again four more times (1834, 1839, 1844 and 1850) and his door in Dresden was always open to young Norwegian artists journeying south. In part through his mentoring of these young artists, he established himself as the master in exile, at the heart of the Norwegian art world. Dahl died in Dresden at the age of 69. CR

M.L. Bang, *Johan Christian Dahl 1788–1857: Life and Works* (3 vols), Oslo 1987.

F. Friborg, *Nature Piece by Piece: Johan Christian Dahl and the Danish Golden Age*, Copenhagen 1999.

Johan Christian Dahl 1788 – 1857 Jubileumsutstilling, exh. cat., Nasjonalgalleriet, Oslo, and Billedgalleri, Bergen, 1988.

François Diday 1802–1877

François Diday trained at the École supérieure des Beaux-Arts in Geneva and studied landscape with Adam-Wolfgang Töpffer (see overleaf), who encouraged him to paint studies from nature. In 1823 he travelled to Paris, where he worked in the studio of Antoine-Jean Gros (1771–1835) and made copies after Dutch seventeenth-century masters in the Louvre. The following year, the Société des Arts in Geneva awarded him a bursary which enabled him to spend 18 months in Italy, where he visited Turin, Genoa, Rome, Naples and Paestum. But it was his trip to the dramatic scenery of the Bernese Oberland in 1827 which determined his desire to paint the mountains of Switzerland.

Diday's Alpine landscapes were exhibited to great success throughout Europe. In 1840 his *Evening in the Valley* (destroyed in 1848) was bought by King Louis-Philippe (1773–1850) and in 1842 his *Bathers* (Kunstmuseum, Basel) earned him the Croix de la Légion d'honneur. On his death he left most of his fortune to the city of Geneva to establish the Fondation Diday, whose aim was to support young Swiss artists.

Diday's paintings were topographically accurate, and his studio work notable for a high degree of academic finish. His approach, when compared with Calame's, was more realist than poetic. Ever since a damning critique by Baudelaire in his 1845 Salon criticism – 'Calame and Diday. For a long time people were under the impression that this was one and the same artist, suffering from a chronic dualism; but later it was observed that he had a preference for the name Calame on the days that he was painting well' – Diday has been compared unfavourably with Calame.[1] But as Buyssens acknowledges, an in-depth study of his work remains to be done. SH

P. von Allmen and F. Arnoux, *Maximilien de Meuron et les peintres de la Suisse romantique,* exh. cat., Musée d'Art et d'Histoire, Neuchâtel 1984.

D. Buyssens, 'Diday, François', in *Biographisches Lexikon der Schweizer Kunst*, Zurich 1998, I, pp. 261–2.

A. Schreiber-Favre, *François Diday 1802–77: Fondateur de l'école suisse de paysage*, Geneva 1942.

1 Charles Baudelaire, 'The Salon of 1845', in *Art in Paris 1845–1862: Salons and Other Exhibitions Reviewed by Charles Baudelaire*, translated and edited by J. Mayne, London 1965, p. 26, quoted in de Andrés 2006, p. 21.

Thomas Fearnley 1802–1842

Thomas Fearnley was still a teenager when he began two years' study at the Royal Danish Academy of Fine Arts in Copenhagen in 1821. Four years' art training followed in Stockholm but the decisive event of his young career came in 1826 when he met, painted in Norway with, and fell under the sway of Johan Christian Dahl, already the acknowledged master of Norwegian landscape painting. He is now recognised as Dahl's outstanding pupil. Fearnley soon followed Dahl back to Dresden, where he was a professor at the Academy of Fine Arts, and there met Caspar David Friedrich (1774–1840), also an influence on his Romantic–realist conception of landscape. By 1830 he had moved

on to Munich and the beginnings of a successful career there but, peripatetic and sociable, in 1832 he moved on to Italy. He loved the sun and warm weather, and some of his most luminous landscapes and freshest oil sketches date from the three years he spent there. Heading home, Fearnley spent the summer of 1835 in Switzerland painting small, radiant Alpine landscapes, many of them showing that country's most prominent natural landmarks. A Paris sojourn followed. Two years later he was in England – his grandfather was a Yorkshireman – visiting London and painting in the Lake District. Everywhere, he produced scintillating small panels and canvases full of fine detail and an overarching sense of ambient atmosphere. Typhoid struck and he died in Munich before his 40th birthday. CR

Nature's Way: Romantic landscapes from Norway. Oil studies, watercolours and drawings by Johan Christian Dahl (1788–1857) and Thomas Fearnley (1802–1842), exh. cat., Whitworth Art Gallery, Manchester, and Fitzwilliam Museum, Cambridge, 1993.

Johann Gottfried Steffan

1815–1905

Johann Gottfried Steffan was born in Wädenswil on Lake Zurich, where he was apprenticed as a lithographer. In 1833 he moved to Munich where he studied painting under the history painter Clemens Zimmermann (1788–1863) at the Academy of Fine Arts during the day, and drawing in the evenings with, among others, Peter von Cornelius (1783–1867) and Julius Schnorr von Carolsfeld (1794–1867). In the summer of 1840 he made his first study trips to Lake Walensee, Grisons (the easternmost canton) and the Rigi. Five years later, he travelled to Italy, visiting Lake Garda, Venice and South Tyrol. Although based in Munich he concentrated on lake and mountain landscapes, visiting Bavaria and Switzerland on a number of occasions to make studies in pencil and oil for his studio compositions, many of which were painted as commissions. Steffan's studio became the focus for Swiss artists in Munich. In 1848, along with Rudolf Koller (1828–1905), Johann Caspar Bosshardt (1823–1887) and Arnold Böcklin (1827–1901), he founded the Schweizer, whose aim was both to foster the Swiss way of life in the city, and to help fellow countrymen in need. Koller called him the 'German Calame', because of his preference for mountains, waterfalls and lakes. SH

E. Sandor-Schneebeli, *Johann Gottfried Steffan. Landschaftsmaler (1815–1905). Mit einem Werkverzeichnis der Gemälde aktualisiert von Adrian Scherrer*, Wädenswil 2009.

A. Scherrer, *Grüner Heinrich. Lebensläufe zwischen Scheitern und Erfolg. Johann Gottfried Steffan und die Schweizer Maler in München 1840 bis 1890*, exh. cat., Seedamm Kulturzentrum, Pfäffikon, and Villa Grünenberg, Wädenswil 2005.

Adam-Wolfgang Töpffer

1766–1847

Born in Geneva, Adam-Wolfgang Töpffer trained initially as an engraver in Lausanne, where he illustrated the second volume of Horace-Bénédict de Saussure's *Voyage dans les Alpes* in 1786. He first visited Paris in 1789, returned in 1791 to study under the history painter Joseph-Benoît Suvée (1743–1807), and went back a third time in 1807 to act as drawing master to Joséphine Bonaparte (1763–1814). From 1787 he accompanied Pierre-Louis de la Rive (1753–1817) on painting expeditions in the environs of Geneva, and quickly developed an interest in the life of the local villages, particularly celebrations, fairs, weddings and harvests, subjects which featured in the idyllic landscapes he composed in the studio, using the oil sketches he had made of the scenery as backgrounds. These pastoral landscapes were popular both in Switzerland and in France, where he exhibited at the Salons of 1804 and 1812, gaining a gold medal at the latter. The sensitivity to both location and atmosphere of his *plein-air* studies of the countryside around Geneva would be replicated in the

work of the Barbizon painters in France. In 1816 he visited England and exhibited at the Royal Academy. He was greatly influenced by English painting, notably in his own practice of working outdoors, but also in his caricatures, for which the celebrated English satirist William Hogarth (1697–1764) acted as inspiration. SH

A. de Andrés, *Westwind. Zur Entdeckung des Lichts in der Schweizer Landschaftsmalerei des 19. Jahrhunderts. Vent d'Ouest. La découverte de la lumière dans la peinture suisse de paysage au XIXe siècle*, exh. cat., Seedamm Kulturzentrum, Stiftung Charles und Agnes Vögele, Pfäffikon 2000.

L. Boissonnas, 'Wolfgang-Adam Töpffer', *La Bibliothèque des Arts*, Lausanne 1996, pp. 26–8, 74–7.

Caspar Wolf 1735–1783

Caspar Wolf was born into a family of cabinet makers in the village of Muri in the northern canton of Aargau. In 1749 he went to study in Konstanz under the episcopal court painter Johann Jakob Anton von Lenz (1701–1764). By 1760 he had returned to Muri, where he worked as a decorative painter. From 1769 to 1771 he was in Paris, working in the studio of Philippe Jacques de Loutherbourg (1740–1812). Two years later, in 1773, he made his first sketching tour of the Alps. In that same year the Berne publisher Abraham Wagner (1734–1782)

commissioned a series of nearly 200 Alpine landscapes, for which Wolf made numerous sketches in pencil and oil. Published in 1777 as *Remarkable Views of the Swiss Mountains*, it was followed by a French edition in 1780–1, with 24 coloured aquatints by Jean-François Janinet (1752–1814).

In 1781 Wolf travelled to Germany, including Düsseldorf, where he painted watercolours of Alpine landscapes for the Prince Elector's palaces. He died in Heidelberg during his return journey to Switzerland. SH

Y. Boerlin-Brodbeck, *Caspar Wolf 1735–1783. Landschaft im Vorfeld der Romantik*, exh. cat., Kunstmuseum, Basel 1980.

A. Haldemann, S. Kunz, C. Reichler and B. Wismer, *Caspar Wolf – Gipfelstürmer zwischen Aufklärung und Romantik*, exh. cat., Museum Kunst Palast, Düsseldorf 2009–10.

W. Raeber, *Caspar Wolf, 1735–1783: sein Leben und sein Werk: ein Beitrag zur Geschichte der Schweizer Malerei des 18. Jahrhunderts*, Aarau/Frankfurt/Salzburg/Munich 1979

Robert Zünd 1827–1909

Born in Lucerne, Robert Zünd trained initially with Jakob Schwegler (1793–1866) and Joseph Zegler (1812–1885). He moved to Geneva in 1848, studying first with François Diday (see page 85) and then with Alexandre Calame (see page 84). The latter was a great influence on his early

work, although Zünd preferred to paint the more tranquil region of the Alpine foothills than the dramatic scenery of the Alps themselves. In 1851 he moved to Munich, where he met Rudolf Koller (1828–1905), and it was through walks with the latter, particularly in the region of Lake Walensee in the autumn of 1852, that the two developed a similar realistic attitude to nature. From 1852 he often visited Paris, where he studied seventeenth-century Dutch and French paintings in the Louvre. He was also influenced by the artists of the Barbizon School. His first major work, *The Harvest* (Kunstmuseum, Basel), dates from 1859. Four years later, in 1863, he settled back in his home town of Lucerne, and from then on painted principally the landscape around the town. SH

S. Neubauer, *Robert Zünd*, exh. cat., Kunstmuseum, Lucerne 2004.

Natasha Podro

Norway

Norway has suffered centuries of rule by other Scandinavian powers. In the 1770s, it is ruled by Denmark, as it has been since 1536. The Danish government prevents it from competing in international trade, and drags it into costly wars with Sweden.

Norway's natural resources (notably fishing, timber and whaling) bring a certain level of prosperity, but the four-year 'Little Ice-Age' in the middle of the eighteenth century results in the failure of crops and the death of thousands of people and a third of Norway's cattle.

The nineteenth century in Norway is to see a new level of independence, a healthier economy and a cultural revival. There is renewed interest in Norwegian folk tales, the tourist industry expands, and a school of distinctly indigenous landscape painting develops.

Switzerland

At the end of the eighteenth century, Switzerland has already been a federal republic for 500 years. It incorporates three main distinct cultural regions, speaking French, German and Italian respectively, and a small community which speaks Romansh. It is divided into 'cantons', each of which has its own constitution and parliament, and enjoys a high degree of independence.

The canton system, originally designed to enable trade to flourish throughout the region, has proved remarkably stable and has led to Switzerland becoming one of the richest countries in the world.

Norway	Switzerland	Norway	Switzerland

Norway

Switzerland

Norway

Switzerland

1806 The Société Suisse des Beaux-Arts is formed on a wave of nationalism resulting from the reinstitution of the Confederation.

1780s

1788 Johan Christian Dahl (1788–1857) is born in Bergen.

1790s

1798 The revolutionary French government invades Switzerland and imposes the short-lived Helvetic Republic. Centralised bureaucratic rule replaces the independence of the cantons and the aristocratic rule of city states such as Zurich and Geneva. An uprising in Nidwalden is violently crushed by the French army.

1810s

1811 Dahl enters the Royal Danish Academy of Fine Arts in Copenhagen, the official capital of Norway.

1810 Alexandre Calame (1810–1864) is born in Vevey.

1814 Following the defeat of Napoleon's army, Sweden invades Danish territory and takes over sovereignty of Norway under the Treaty of Kiel. This is rejected by Norway which makes a bid for independence, but a further Swedish invasion leads to a compromise in which Norway instigates its own constitution, but Sweden retains sovereignty.

1815 Swiss independence is fully re-established at the Congress of Vienna. Switzerland declares neutrality from all international wars, although its troops continue to fight for foreign governments.

1800s

1807 Napoleon (1769–1821) and the Russian Tsar, Alexander I (1777–1825) force Denmark to side with them against Britain which provokes a blockade against Norway. The financial consequences for Norway are severe.

1800–02 Russian and Austrian forces invade Switzerland. The Swiss refuse to fight in the name of the Helvetic Republic.

1803 Napoleon (1769–1821) largely restores Swiss autonomy under the Act of Mediation.

1818 Dahl moves to Dresden, where he meets Caspar David Friedrich. (1774–1840)

Norway	Switzerland	Norway	Switzerland

1820s

1820–1 Dahl travels to Italy to study Old Masters.

1826 Thomas Fearnley (1802–1842) spends the summer in Norway with Dahl learning to 'paint from Nature'.

1827 François Diday (1802–1877) visits the Bernese Oberland and is inspired to paint Swiss landscapes.

1829 Alexandre Calame studies under Diday in Geneva.

1830s

1832 Peder Balke (1804–1887) travels to the North Cape of Norway in search of ever more rugged and harsh landscapes to paint.

1835 Fearnley spends three months in Switzerland painting Alpine landscapes.
 Balke visits Dresden where he meets Dahl for the first time.

1836 Dahl is involved in founding the Kunstforrening (Art Association) to give Norwegian artists an exhibition venue.

about 1830–70 In France, a group of painters including Jean-Baptiste-Camille Corot (1796–1875), Jean-François Millet (1814–1875) and Théodore Rousseau (1812–1867) begin to form the 'Barbizon School'. Their scenes of rural life and nature are to be an inspiration to Swiss landscape artists such as Calame.

1834 Calame opens his own studio in Geneva.

1837 Calame visits Paris.

1837 Dahl is instrumental in the establishment of a National Gallery in Christiania (now Oslo).
 Fearnley visits London and the Lake District.

1839 In Zurich, one of many clashes occurs between the conservative Catholic population and the liberal government.

1840s

1841–4 Peter Asbjørnsen (1812–1885) and Jørgen Moe (1813–1882) collect the *Norwegian Folktales*, a project indicative of Norway's pride in its increasing independence. It uses Norwegian dialect words as a deliberate move away from Danish.

1845 Balke travels to London and Paris; in 1847 King Louis Philippe commissions some North Norwegian scenes from him (although these are never completed).

1840 The Société Suisse des Beaux-Arts holds its first 'Tournu', a touring exhibition of national art. These are held regularly until the mid-20th century.

1847 Civil War breaks out when a group of Catholic cantons, the Sonderbund, try to set up a separate alliance. The war lasts less than a month with fewer than 100 casualties.

1848 Johann Steffan (1815–1905) forms the 'Schweizer', a group of Swiss artists working in Munich, which also includes Rudolf Koller (1828–1905).

Norway	Switzerland	Norway	Switzerland
1850s		**1880s**	
1859 Complete religious freedom is granted in Sweden and Norway.		**1884** Norway's cabinet is no longer answerable to the Swedish King, but to Parliament.	**1880** Publication of *Heidi* by Johanna Spyri (1827–1901).
1860s			
1864 Inspired by Norwegian folk music, composer Rikard Nordraak (1842–1866) writes *Yes, We Love This Land*, which becomes the Norwegian national anthem.	**1860** Jacob Burckhardt (1818–1897) publishes *The Civilisation of the Renaissance in Italy*.	**1887** Balke dies, forgotten as a painter.	
		1890s	
		1893 Edvard Munch (1863–1944) paints *The Scream*.	
1867 Henrik Ibsen (1828–1906) publishes *Peer Gynt*, which is based on one of the *Norwegian Folktales*.	**1866** Painters dissatisfied with the Société des Beaux-Arts form a new body, the Société des Peintres et des Sculpteurs Suisses.		

Postscript

In 1905 Norway finally achieves independence. The Swedish king, Oscar II (1829–1907), relinquishes the crown after a referendum produces an almost unanimous vote to end the union with Sweden.

Switzerland's federal structure remains in place today, although a new constitution was adopted in 1999. It has remained neutral since 1815 and only joined the United Nations in 2002.

Norway	Switzerland
1868 Edvard Grieg (1843–1907) writes his Piano Concerto in A minor.	
1870s	
1879 Ibsen publishes his naturalist play *A Doll's House* which controversially criticises nineteenth-century marriage conventions.	**1874** The constitution is revised to eliminate corruption. Many laws now have to be approved by a referendum: a petition of 100,000 names can force a vote on any new law.

All paintings are from the collection of Asbjørn Lunde.

Knud Baade 1808–1879

Scene from the era of Norwegian Sagas, 1850
Oil on canvas, 87.6 × 119.4 cm
Cat. 8

Peasant's Hut, 1861
Oil on canvas, 34 × 47 cm
Cat. 9

Peder Balke 1804–1887

The Mountain Range 'Trolltindene', about 1845
Oil on canvas, 30.8 × 41.9 cm
Cat. 10

Moonlit View of Stockholm, about 1850
Oil on canvas, 67.3 × 100.3 cm
Cat. 11

Seascape, about 1860
Oil on canvas, 16.8 × 23.2 cm
Cat. 12

Landscape from Finnmark, about 1860
Oil on canvas, 34.9 × 52 cm
Cat. 13

Alexandre Calame 1810–1864

Torrent in the Alps, 1849
Oil on canvas, 57.8 × 76 cm
Cat. 33 · Anker 371

Mountain Torrent before a Storm (The Aare River, Haslital), 1850
Oil on canvas, 98.1 × 137.8 cm
Cat. 2 · Anker 419

Beech Grove, Rocky Foreground, about 1850–5
Oil on canvas, 36 × 50.5 cm
Cat. 32

Stem of a Beech Tree, 1850–5
Oil on card, 45.5 × 33.5 cm
Cat. 34

Mountain Torrent, about 1850–60
Oil on canvas, 28 × 37.5 cm
Cat. 35

View of the Jungfrau Massif seen from Above, Interlaken, about 1854–60
Oil on canvas, 50 × 63 cm
Cat. 37

Valley of Lauterbrunnen, August 1856
Oil on paper, on canvas, 45.4 × 55.6 cm
Cat. 36

Lake Lucerne, Uri-Rotstock, about 1857–61
Oil on canvas, 32.7 × 31.3 cm
Cat. 39 · Anker 670

At Handeck, about 1860
Oil on canvas, 39.4 × 24.5 cm
Cat. 40

Rocky Path, 1860
Oil on paper, laid on board, 25 × 27.4 cm
Cat. 41

Chalets at Rigi, 1861
Oil on canvas, 40.6 × 62.2 cm
Cat. 42 · Anker 755

Cliffs of Seelisberg, Lake Lucerne, about 1861
Oil on canvas, laid on cardboard, 38.4 × 26.4 cm
Cat. 38

The Mythen, about 1861
Oil on canvas, 27 × 37.3 cm
Cat. 43

Souvenir of Lake Lucerne, 1862
Oil on canvas, 51.1 × 42.5 cm
Cat. 46

Riverbed at Rosenlaui, about 1862
Oil on canvas, 41 × 55.3 cm
Cat. 44 · Anker 781

The River Lutschine near Lauterbrunnen, about 1862
Oil on canvas, 31.3 × 52.2 cm
Cat. 45

Johan Christian Dahl 1788–1857

Grotto near Naples, 1821
Oil on paper, 27 × 43 cm
Cat. 14

The Grosser Garten, Dresden, 21 August 1822
Oil on canvas, laid on board, 25 × 34.5 cm
Cat. 15

The Lower Falls of the Labrofoss, 1827
Oil on canvas, 51 × 66 cm
Cat. 1 · Bang 563

Chalk Pit near Maxen, 1835
Oil on canvas, 32.4 × 37.2 cm
Cat. 16 · Bang 790

Fjord Landscape with Menhir, 1837
Oil on canvas, 18 × 26 cm
Cat. 17 · Bang 840

View over Hallingdal, 1844
Oil on canvas, 24.1 × 36.5 cm
Cat. 18 · Bang 1009

Shipwreck on the Coast between Larvik and Frederksvern, 1847
Oil on canvas, 25.7 × 32.4 cm
Cat. 19 · Bang 1071

View of Naerodalen, 1847
Oil on canvas, 26 × 32 cm
Cat. 20 · Bang 1061

View of the Feigumfoss in Lysterfjord, 1848
Oil on canvas, 42 × 57.7 cm
Cat. 21 · Bang 1083

Study of a Rock from Nystuen on Filefjell, 27 August, 1850
Oil on paper, 36 × 46 cm
Cat. 22 · Bang 1114

Mountain Farm, 1854
Oil on canvas, 33 × 48 cm
Cat. 23 · Bang 1152

François Diday 1802–1877

The Wetterhorn with Upper and Lower Grindelwaln Glacier, date unknown
Oil on panel, 44.5 × 58.3 cm
Cat. 5

Thomas Fearnley 1802–1842

View over the Elbe, 1830/30
Oil on canvas, 30 × 47 cm
Cat. 31

Arco Naturale, Capri, before 1833
Oil on canvas, 40.3 × 51.1 cm
Cat. 24

View of Palermo and Monte Pellegrino, 21 June 1833
Oil on paper, 32.3 × 52 cm
Cat. 25

At Carrara, 1835
Oil on paper, laid down on panel, 28 × 38 cm
Cat. 26

Near Meiringen, 10 June 1835
Oil on paper, laid down on canvas, 27.3 × 36.8 cm
Cat. 3

The Mountain Wetterhorn, 18 July 1835
Oil on paper, 30.8 × 28 cm
Cat. 6

Valley of Lauterbrunnen, 26 August 1835
Oil on paper, 27.3 × 33 cm
Cat. 4

Fisherman at Derwentwater, 2 August 1837
Oil on paper on panel, 25.4 × 37.8 cm
Cat. 27

Tree Study, by a Stream, Granvin, 11 July 1839
Oil on panel, 27.9 × 38.9 cm
Cat. 28

View over Romsdal with Romsdalshorn in the Background, 1837
Oil on canvas, 45.7 × 61.3 cm
Cat. 29

Sorrento, 1840
Oil on canvas, 38.5 × 55 cm
Cat. 30

Johann Gottfried Steffan 1815–1905

Near Meiringen (The Wetterhorn), 1846
Oil on canvas, 34 × 35.9 cm
Cat. 7

Lake Brienz, 12 September 1865
Oil on canvas, 36.4 × 46 cm
Cat. 47

The Hintersee, near Berchtesgaden, 1871
Oil on canvas, 26 × 46.4 cm
Cat. 48

Adam Töpffer 1766–1847

Study of Rocky Lakeside Landscape (possibly Lake Geneva), 1812
Oil on cardboard, 21 × 29.2 cm
Cat. 49

Caspar Wolf 1735–1783

The Geltenbach Falls in the Lauenen Valley with an Ice Bridge, about 1778
Oil on cardboard, 29.1 × 20.3 cm
Cat. 50

Robert Zünd 1827–1909

Storm Study, date unknown
Oil on canvas, 40.3 × 27.6 cm
Cat. 51

Bibliography

94

A. Aaserud and K. Ljøgodt, *Den Ville Natur. Sveitsisk og Norsk Romantikk Malerier fra Asbjøn Lundes samling*, exh. cat., Nordnorsk Kunstmuseum, Tromsø, Bergen Kunstmuseum, Scandinavia House, New York, 2007–8

J. Addison, *Remarks on Several Parts of Italy, &c in the years 1701, 1702, 1703*, London 1705

P. von Allmen and F. Arnoux, *Maximilien de Meuron et les peintres de la Suisse romantique*, exh. cat., Musée d'Art et d'Histoire, Neuchâtel, 1984

A. de Andrés, *Alpine Views. Alexandre Calame and the Swiss Landscape*, exh. cat., Sterling and Francine Clark Art Institute, Williamstown, 2006

A. de Andrés, *Westwind. Zur Entdeckung des Lichts in der Schweizer Landschaftsmalerei des 19. Jahrhunderts. Vent d'Ouest. La découverte de la lumière dans la peinture suisse de paysage au XIXe siècle*, exh. cat., Seedamm Kulturzentrum, Stiftung Charles und Agnes Vögele, 2000

V. Anker, *Alexandre Calame. Vie et Oeuvre. Catalogue raisonné de l'oeuvre peint*, Fribourg 1987

V. Anker, *Alexandre Calame (1810–1864), dessins, catalogue raisonné*, Wabern-Berne 2000

Peder Balke: Ein Pionier der Moderne, exh. cat., Kunsthalle, Krems, and Ordrupgaard, Copenhagen, 2008–2009

M.L. Bang, *Johan Christian Dahl 1788–1857: Life and Works* (3 vols), Oslo 1987

M.L. Bang, 'Joseph Anton's Koch's 'Lauterbrunnental' and Johan Christian Dahl' in *På Klassik Grund: The Thorvaldsen Museum Bulletin*, Copenhagen 1989

P.G. Berman, 'Making Family Values: Narratives of Kinship and Peasant Life in Norwegian Nationalism,' in M. Facos and S.L. Hirsh, eds., *Art, Culture and National Identity in Fin-de-Siècle Europe*, Cambridge 2003

P.G. Berman, *In Another Light: Danish Painting in the Nineteenth Century*, London 2007

Y. Boerlin-Brodbeck, *Caspar Wolf 1735–1783. Landschaft im Vorfeld der Romantik*, exh. cat., Kunstmuseum, Basel, 1980

L. Boissonnas, 'Wolfgang-Adam Töpffer', *La Bibliothèque des Arts*, Lausanne 1996, pp. 26–8, 74–7

A Brush with Nature: The Gere Collection of Landscape Oil Sketches, National Gallery, London, 1999

E. Burke, *Philosophical Enquiry into the Origin of our Ideas of the Sublime and Beautiful*, London 1757

D. Buyssens, 'Diday, François', in *Biographisches Lexikon der Schweizer Kunst*, Zurich 1998, pp. 261–2

Johan Christian Dahl 1788 – 1857 Jubileumsutstilling, exh. cat., Nasjonalgalleriet, Oslo, and Billedgalleri, Bergen, 1988

F. Deuchler, M. Roethlisberger and H.A. Lüthy, *La Peinture Suisse du moyen âge à l'aube du XXe siècle*, Geneva 1975

D.W. Freshfield, *The Life of Horace Bénédict de Saussure*, London 1920

F. Friborg, *Nature Piece by Piece: Johan Christian Dahl and the Danish Golden Age*, Copenhagen 1999

T. Gunnarsson, *Nordic Landscape Painting in the Nineteenth Century*, New Haven and London 1990

A. Haldemann, S. Kunz, C. Reichler and B. Wismer, *Caspar Wolf – Gipfelstürmer zwischen Aufklärung und Romantik*, exh. cat., Museum Kunst Palast, Düsseldorf, 2009–10

W. Hauptmann, *La Suisse Sublime vue par les peintres voyageurs 1770–1914*, exh. cat., Fondation Thyssen-Bornemisza, Lugano 1991

C. Klemm, *Von Anker bis Zünd. Die Kunst im jungen Bundesstaat 1848–1900*, exh. cat., Kunsthaus Zürich and Musée d'art et d'histoire, Geneva, 1998

P. Kvaerne and M. Malmanger (eds.), *Un peintre norvégien au Louvre: Peder Balke (1804–1887) et son temps*, Oslo 2006

K. Ljøgodt, 'Wild Nature: Swiss and Norwegian Landscape Painting,' in *Den Ville Natur: Sveitsisk og Norsk Romantikk: Malerie fra Asbjørn Lunde*

samling, *New York*, exh. cat., Tromsø 2007, pp. 149–154.

K. Ljøgodt, 'Knud Baade als Historienmaler', *Münchner Jahrbuch der bildenden Kunst*, Dritte Folge Band LIX 2008, pp. 289–99

A Mirror of Nature: Nordic landscape painting, 1840–1910, exh. cat., Statens Museum for Kunst, Copenhagen 2006

K. Monrad, 'The Dutch Dimension in Danish Golden Age Landscape Painting,' in *Two Golden Ages: Masterpieces of Dutch and Danish Painting*, exh. cat., Rijksmuseum, Amsterdam, and Statens Museum for Kunst, Copenhagen, 2001, pp. 16–71.

Nature's Way: Romantic landscapes from Norway. Oil studies, watercolours and drawings by Johan Christian Dahl (1788–1857) and Thomas Fearnley (1802–1842), exh. cat., Whitworth Art Gallery, Manchester, and Fitzwilliam Museum, Cambridge, 1993

S. Neubauer, *Robert Zünd*, exh. cat., Kunstmuseum, Lucerne 2004

W. Raeber, *Caspar Wolf,*

1735–1783: sein Leben und sein Werk: ein Beitrag zur Geschichte der Schweizer Malerei des 18. Jahrhunderts, Aarau/Frankfurt/Salzburg/Munich 1979

C. Reichler, *La découverte des Alpes et la question du paysage*, Geneva 2002

E. Sandor-Schneebeli, *Johann Gottfried Steffan. Landschaftsmaler 1815–1905. Mit einem Werkverzeichnis der Gemälde aktualisiert von Adrian Scherrer*, Wädenswil 2009

H.B. de Saussure, Voyages dans les Alpes: précédés d'un essai sur l'histoire naturelle des environs de Genève, 4 volumes, Neuchâtel 1779–96

M-L. Schaller, *Annäherung an der Natur. Schweizer Kleinmeister in Bern 1775–1800*, Bern 1990

A. Scherrer, *Grüner Heinrich. Lebensläufe zwischen Scheitern und Erfolg. Johann Gottfried Steffan und die Schweizer Maler in München 1840 bis 1890*, exh. cat., Seedamm Kulturzentrum, Pfäffikon, and Villa Grünenberg, Wädenswil, 2005

A. Schreiber-Fabre, *Alexandre*

Calame, peintre paysage, graveur et lithographe, Lausanne 1934

A. Schreiber-Favre, *François Diday 1802–77: Fondateur de l'école suisse de paysage*, Geneva 1942

W. Stechow, *Dutch Landscape Painting of the Seventeenth Century*, New York 1966

Philip Stewart and Jean Vaché, *The Collected Writings of Rousseau*, vol. 6, Hanover and London 1997

A. Wagner, *Remarkable Views of the Swiss Mountains*, Berne 1777

P. Wegmann, *Caspar David Friedrich to Ferdinand Hodler: A Romantic Tradition. Nineteenth-Century Paintings and Drawings from the Oskar Reinhart Foundation, Winterthur*, exh. cat., Alte Nationalgalerie, Berlin, Los Angeles County Museum of Art, Metropolitan Museum of Art, New York, National Gallery, London, Musée d'Art et d'Histoire (Musée Rath), Geneva, 1993–5

95